Withdrawn

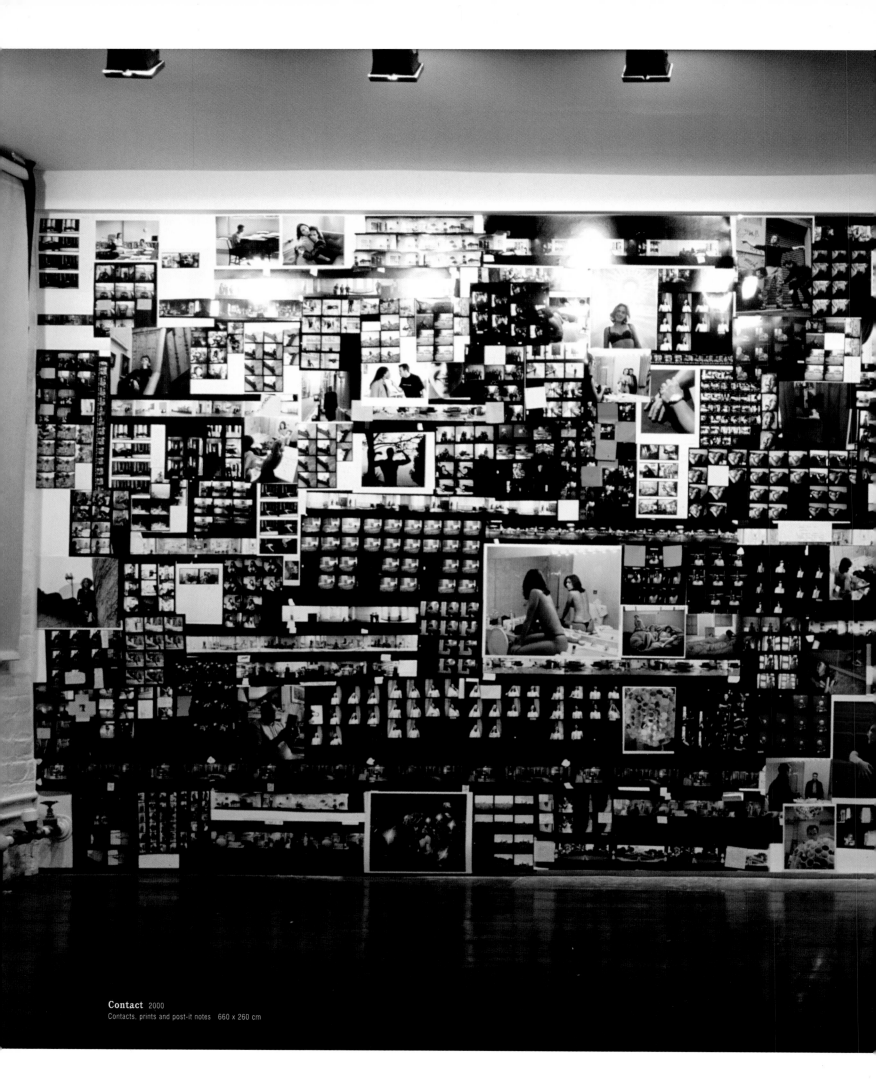

Contact 2000
Contacts, prints and post-it notes 660 x 260 cm

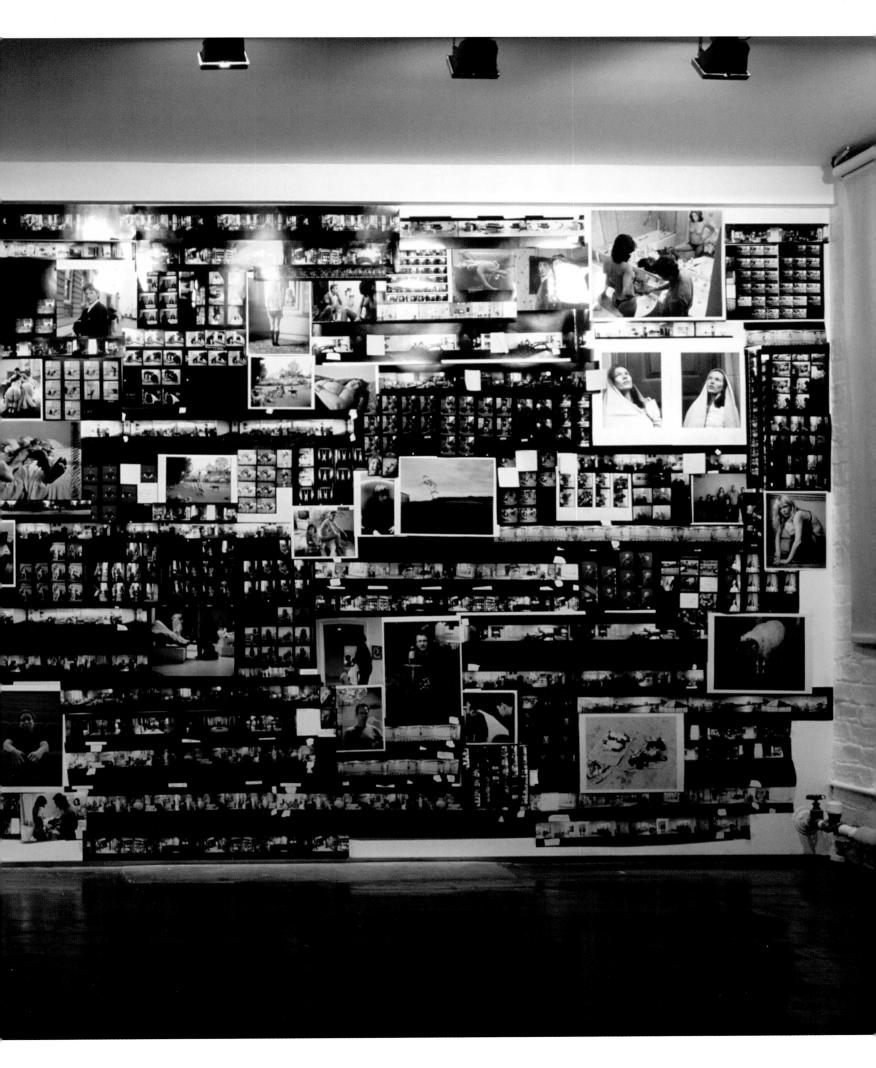

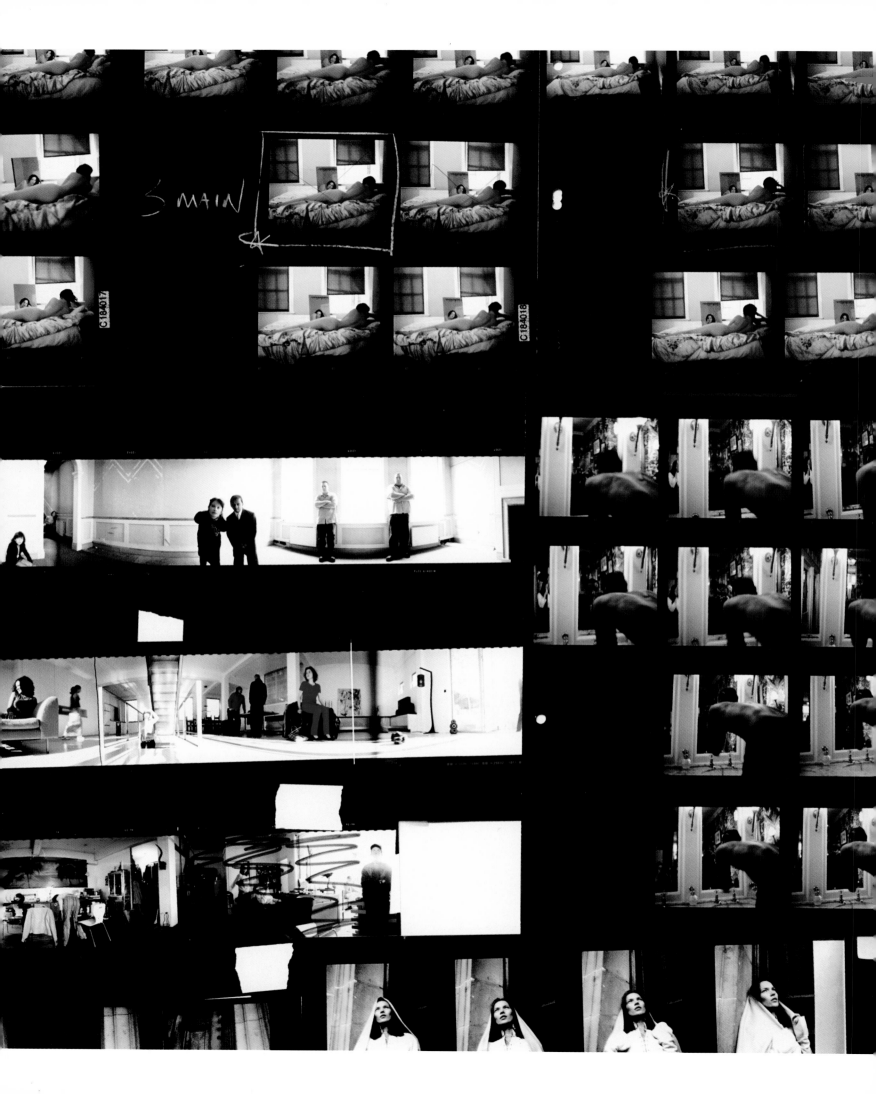

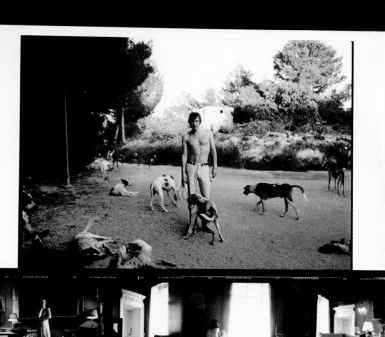

NAKED SECTION

this one
too high

C511926

1 x 12 x

x2

Roll 1

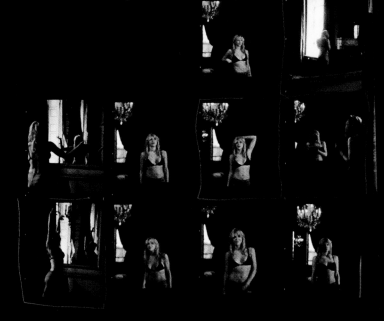

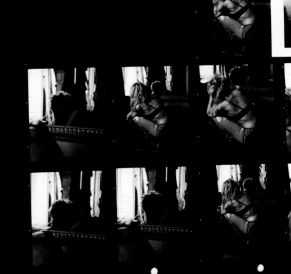

AGFA 50 A AGFA 51

SAM TAYLOR-WOOD

STEIDL

1992

A Gesture Towards Action Painting 1992
Colour photograph

1993

Colours II 1993
Laserprint 106 x 145 cm

16mm 1993
16mm with sound Looped film

1994

Cunt 1994
Letterpress printed from a line block 46.8 x 60.8 cm

Cunt.

Spankers Hill 1994
Colour photograph 32 x 59 cm

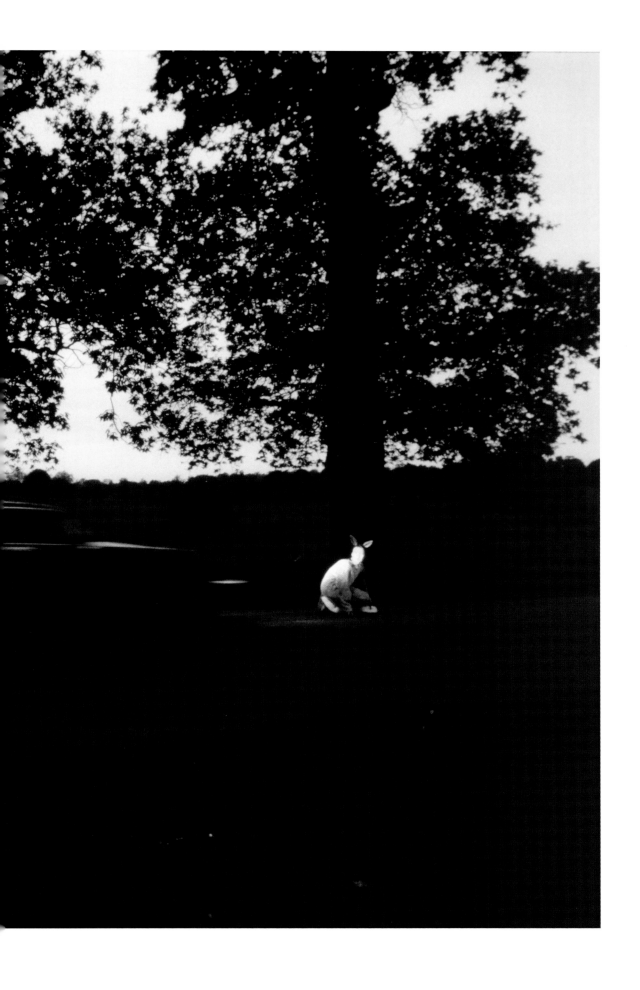

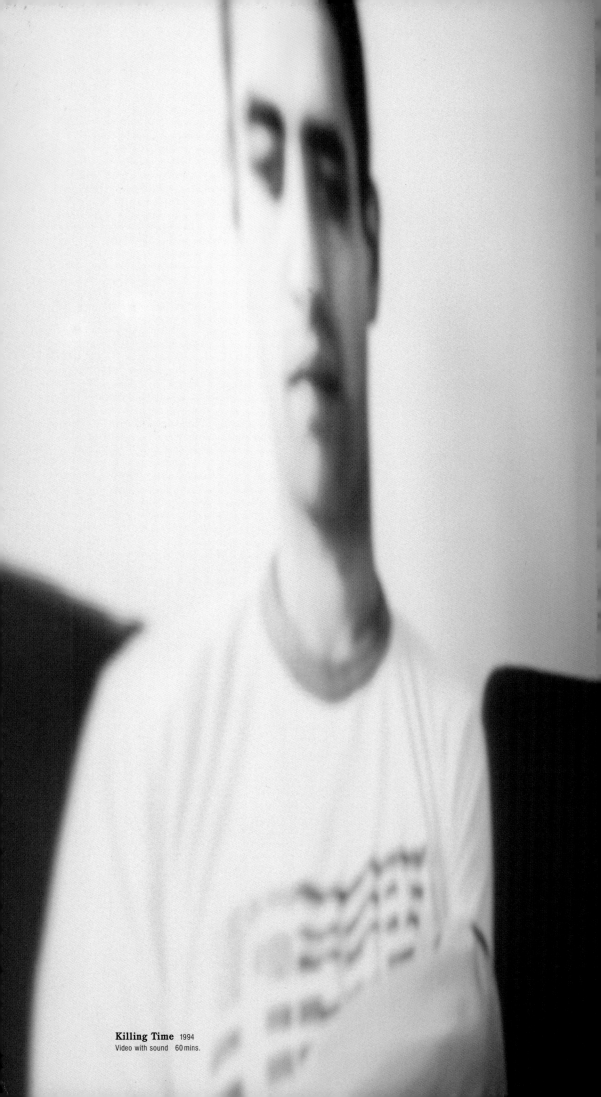

Killing Time 1994
Video with sound 60 mins.

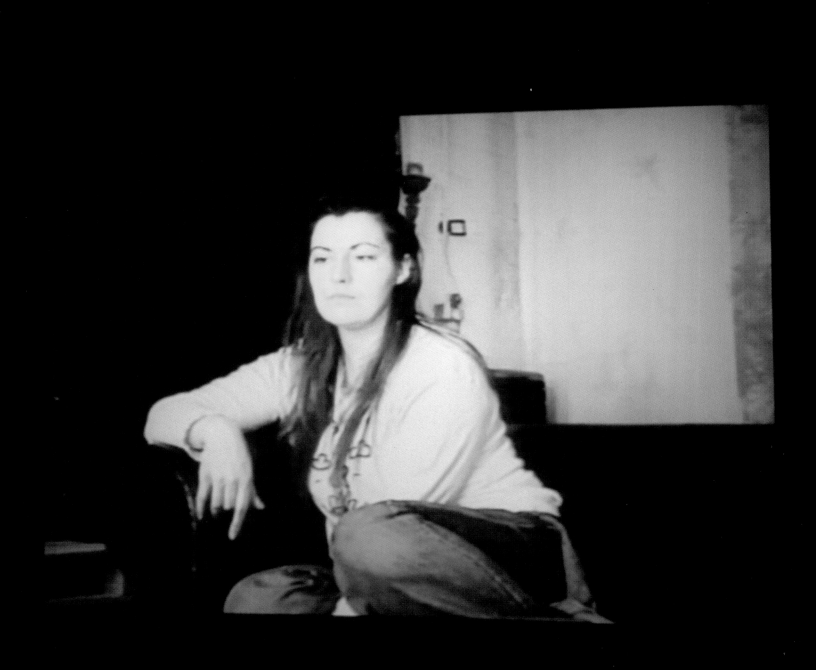

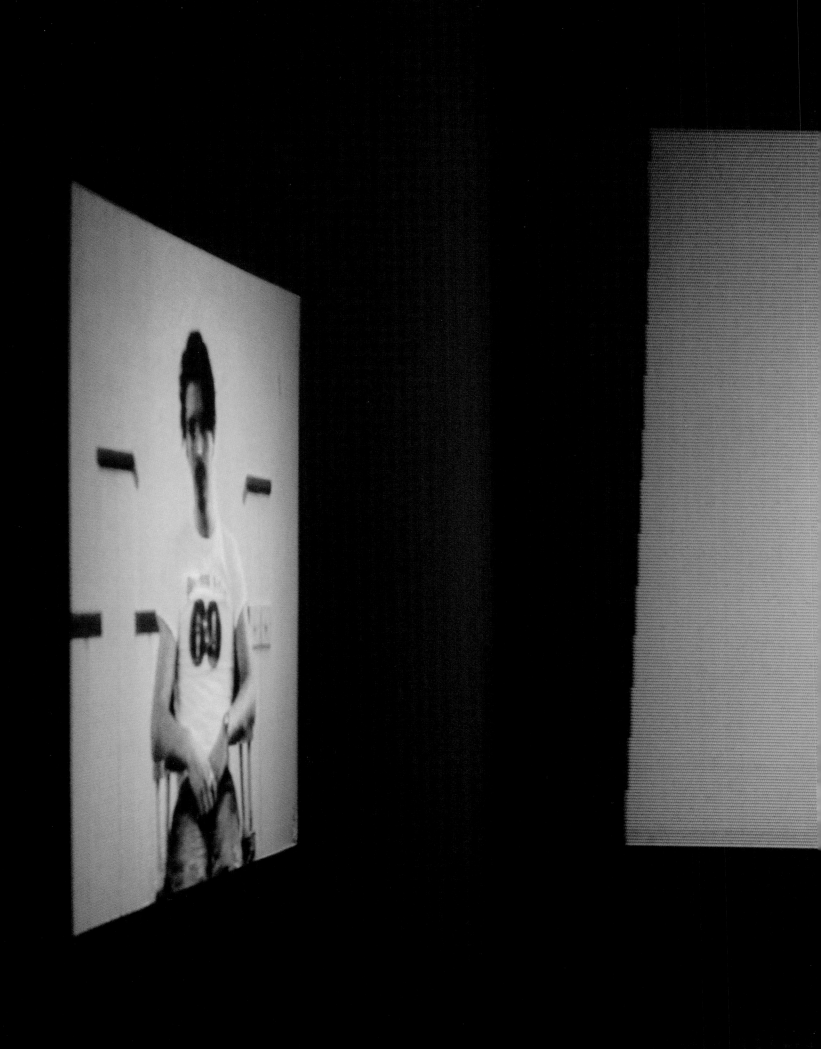

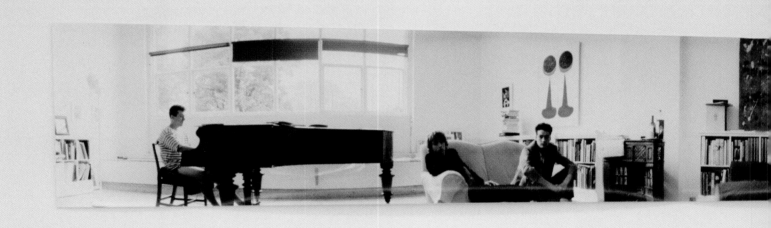

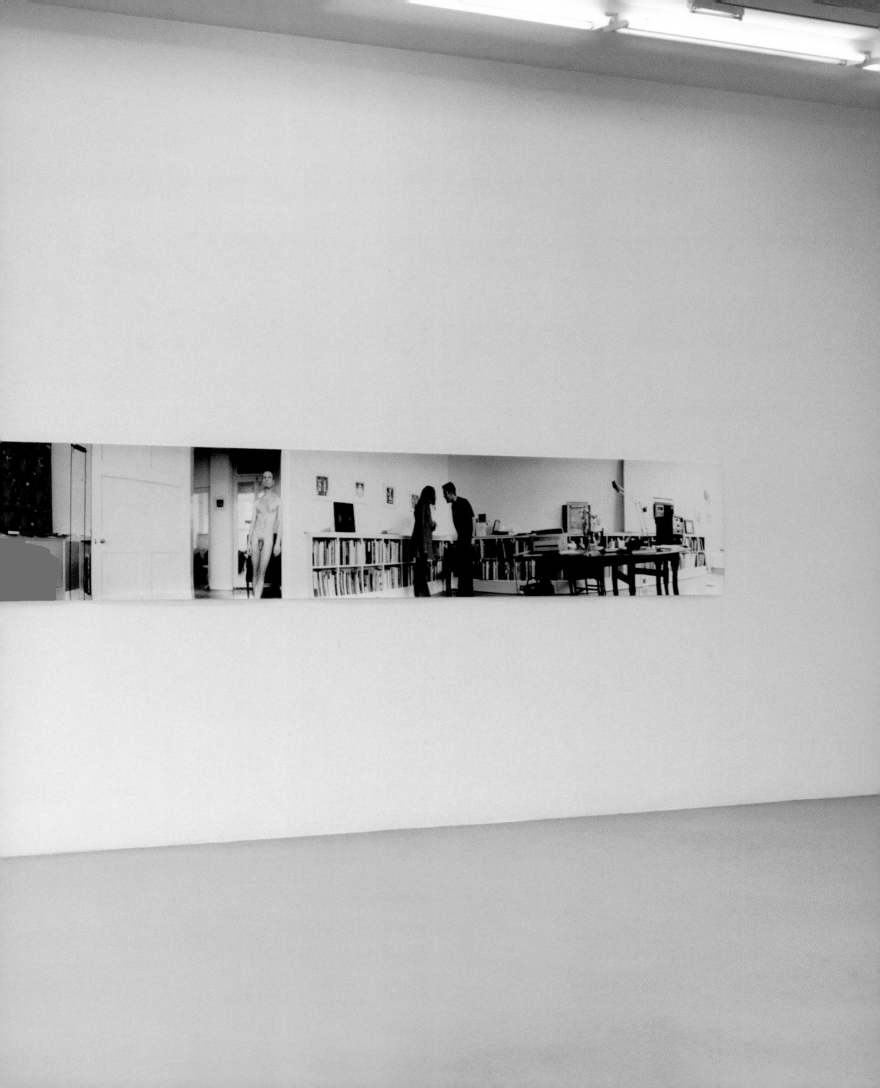

1995

Five Revolutionary Seconds I 1995
Colour photograph on vinyl with sound 72 x 757 cm

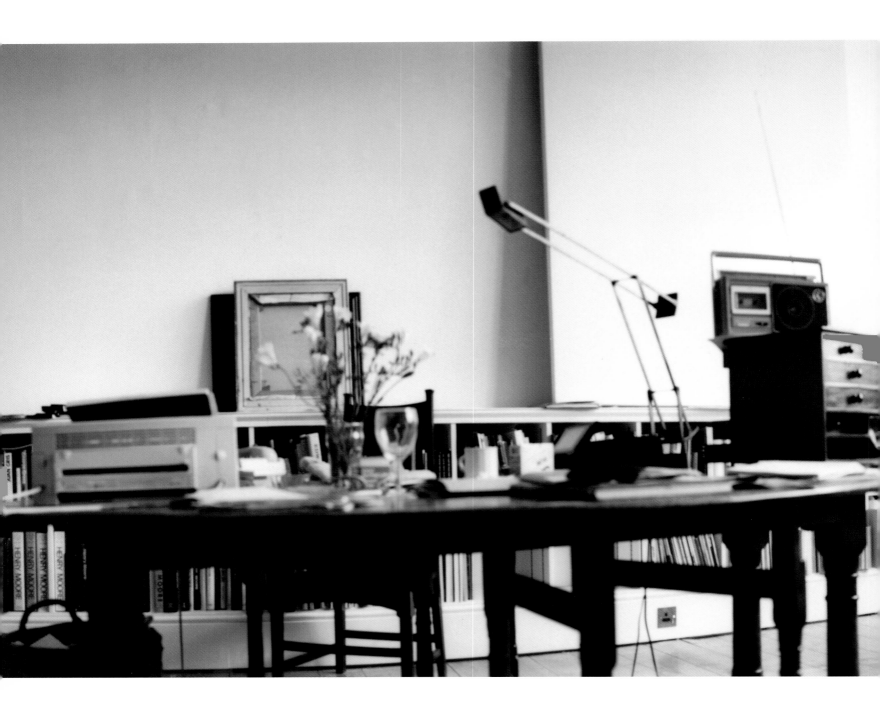

Brontosaurus 1995
Video with sound 10 mins.

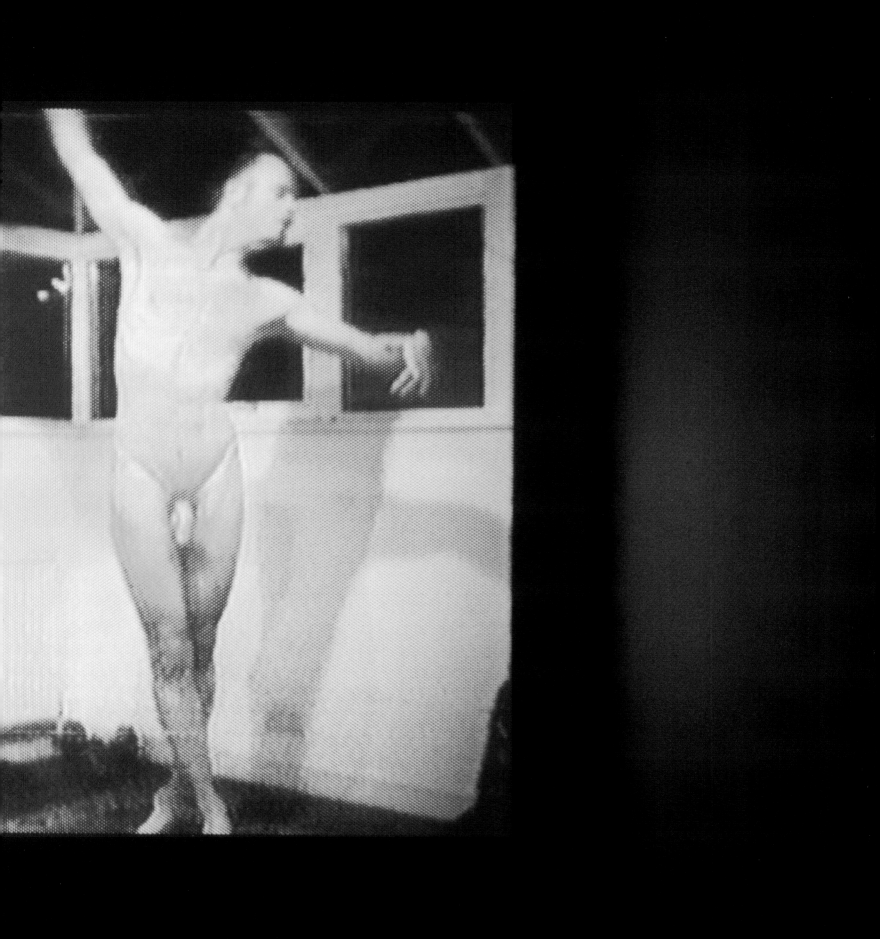

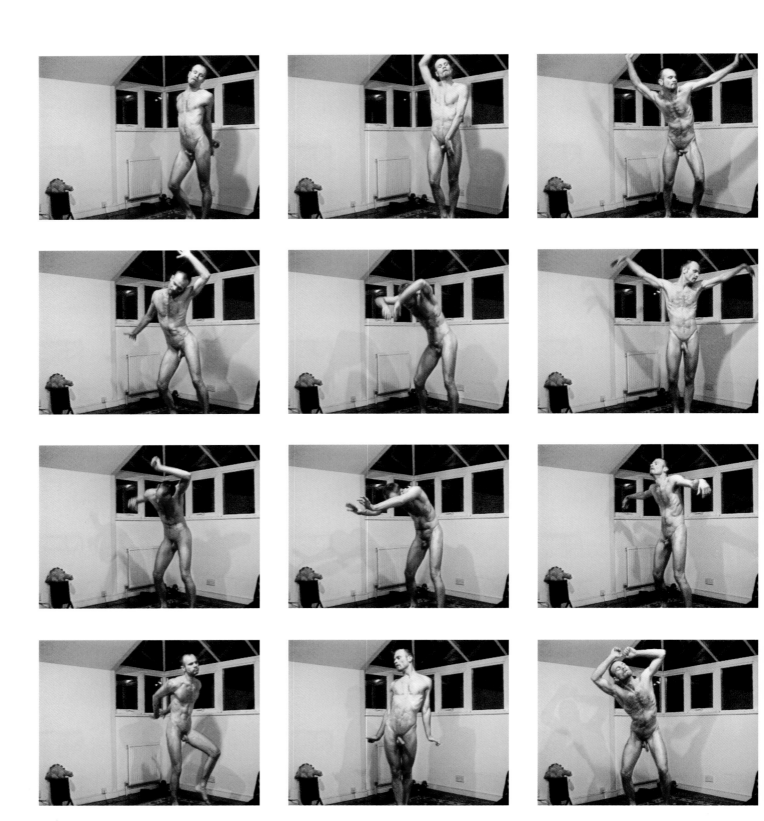

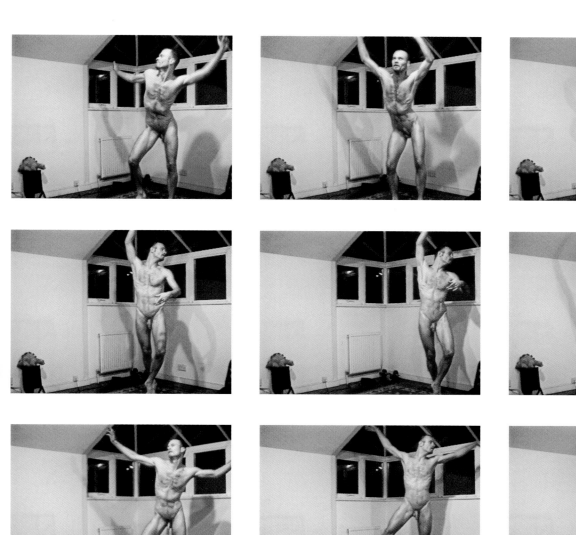
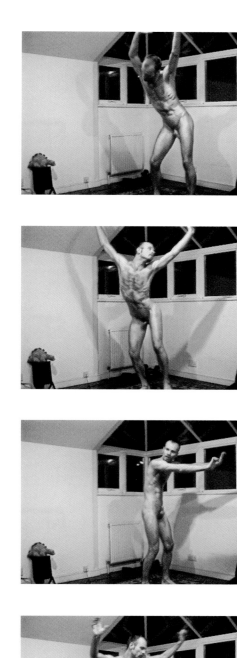

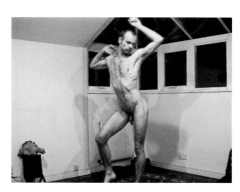
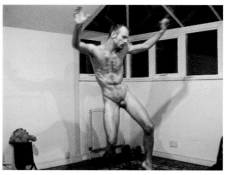

Five Revolutionary Seconds II 1995
Colour photograph on vinyl with sound 72 x 757 cm

Travesty of a Mockery 1995
Video with sound 10 mins.

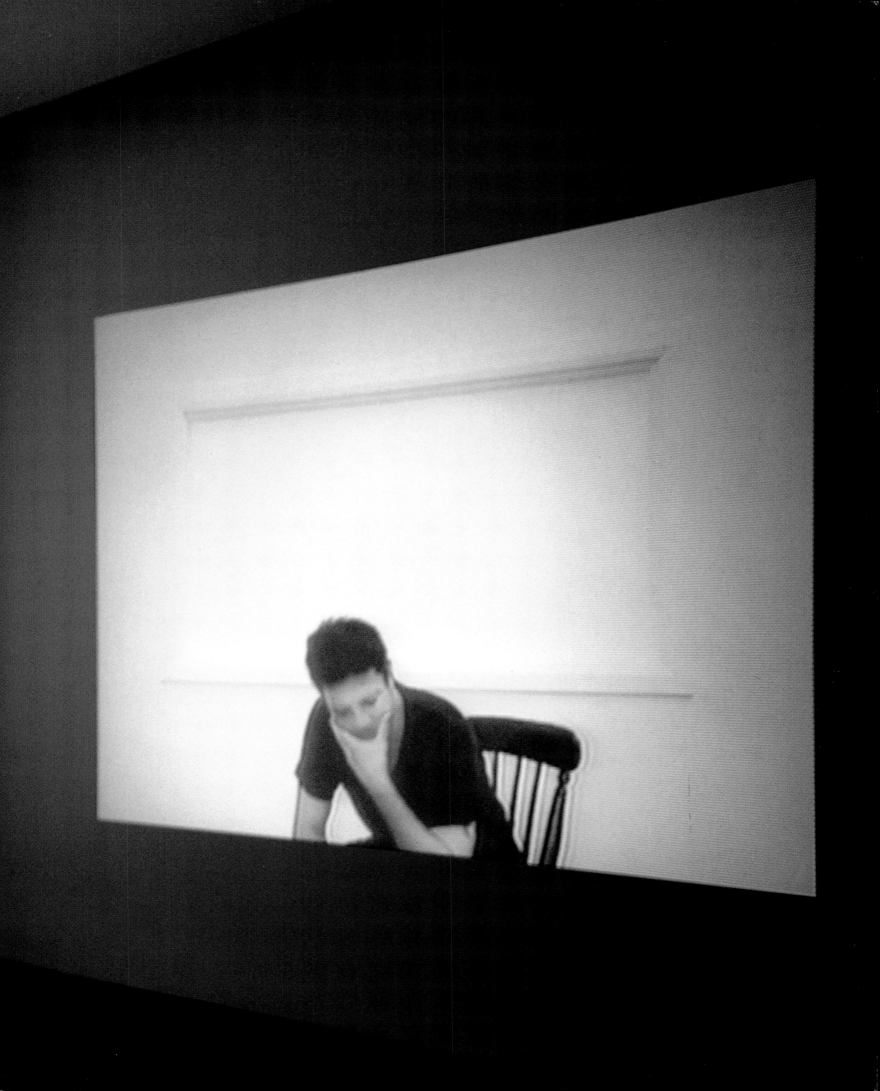

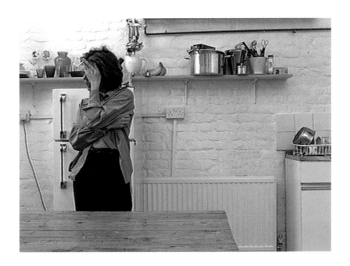
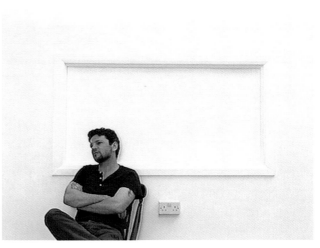
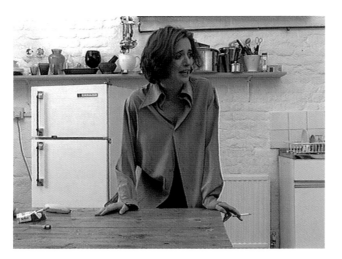

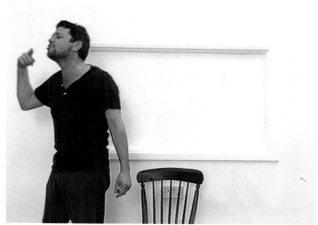

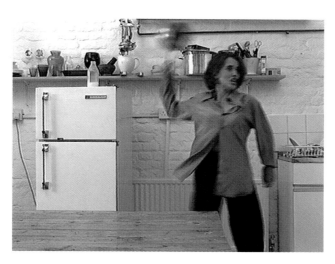
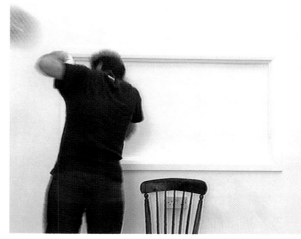

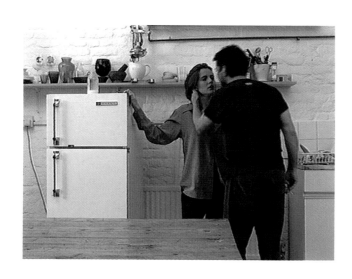

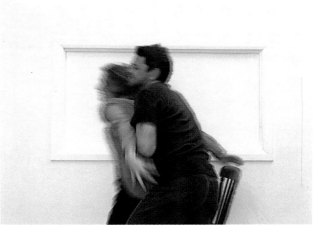
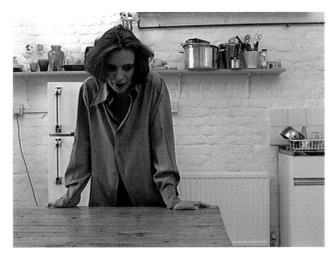
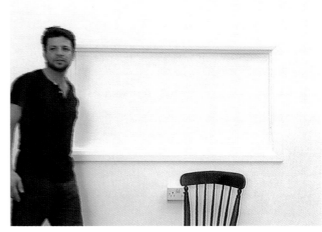

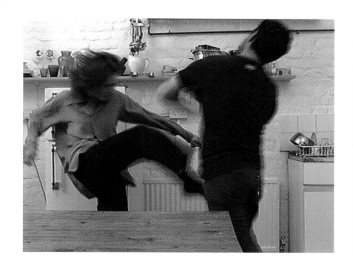

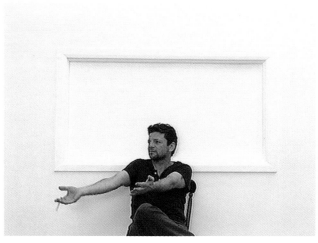

Method in Madness 1995
16mm with sound - 10 mins.

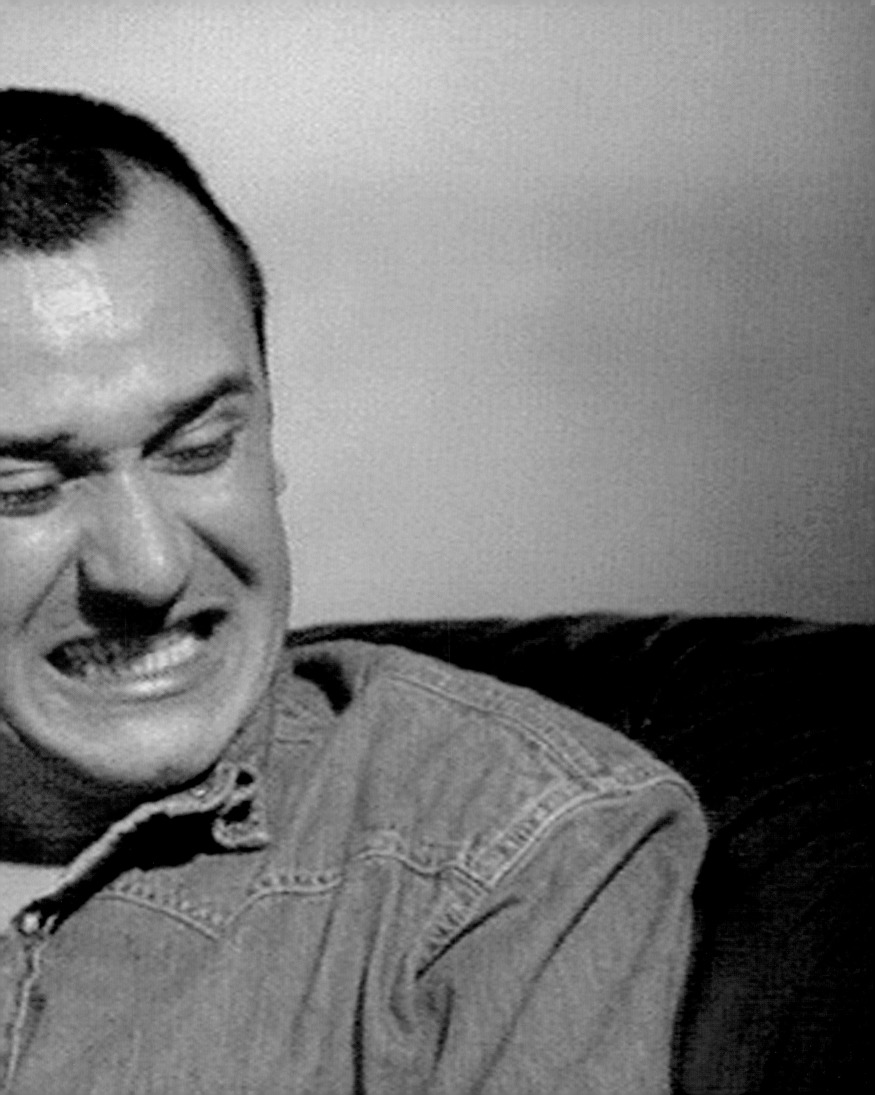

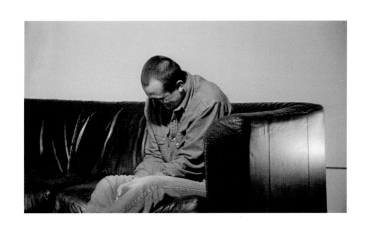

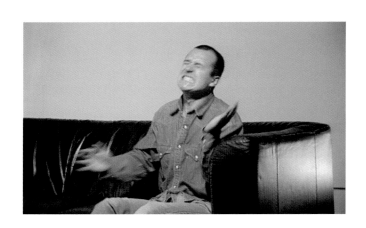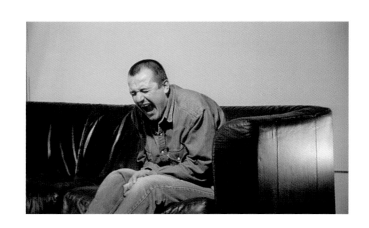

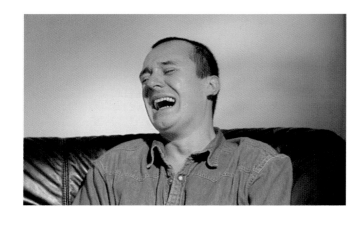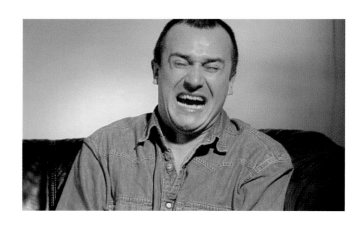

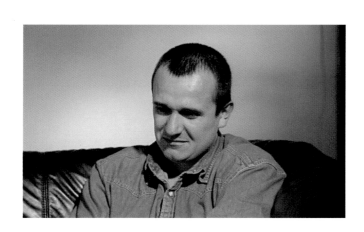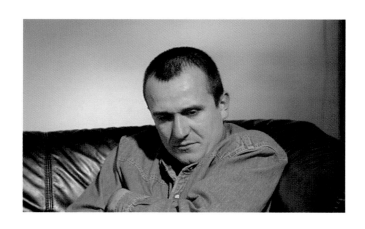

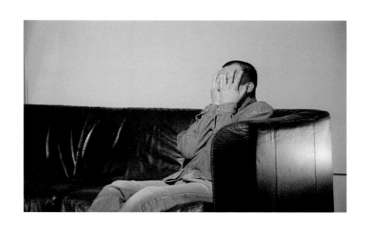

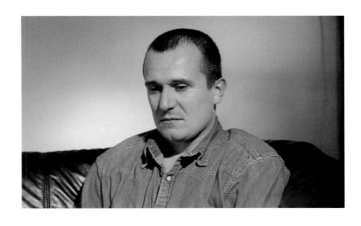
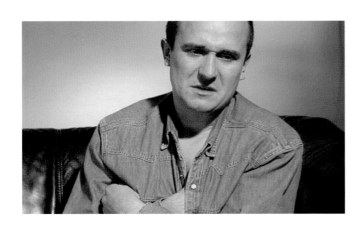
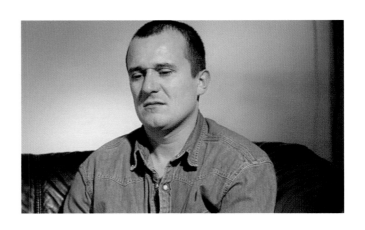

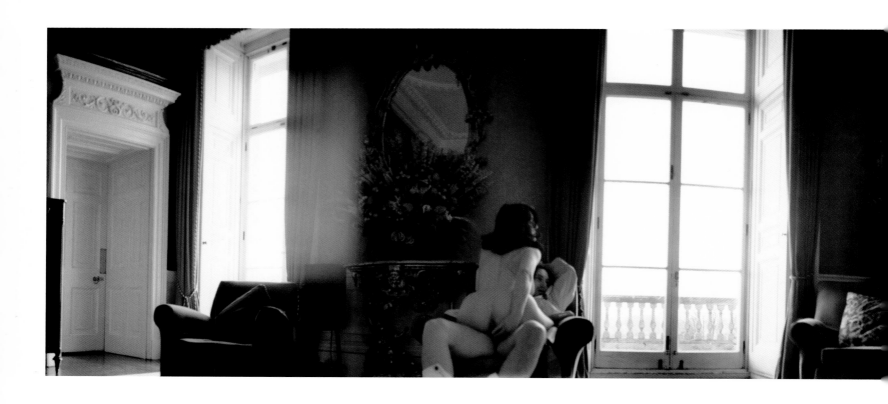

1996

Five Revolutionary Seconds III 1996
Colour photograph on vinyl with sound 72 x 757 cm

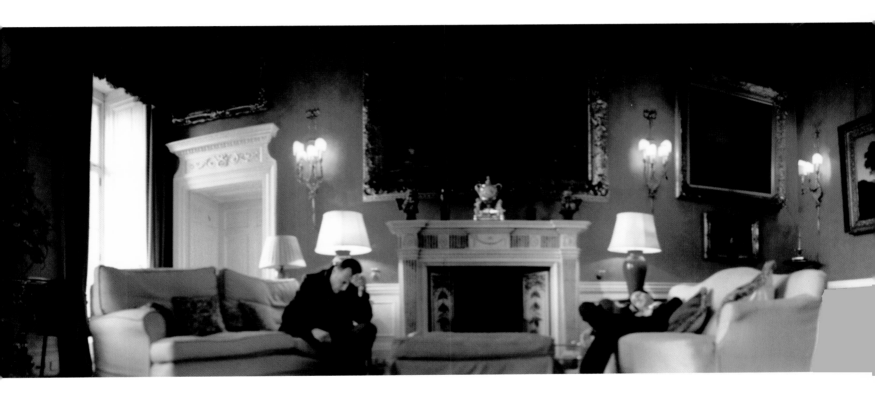

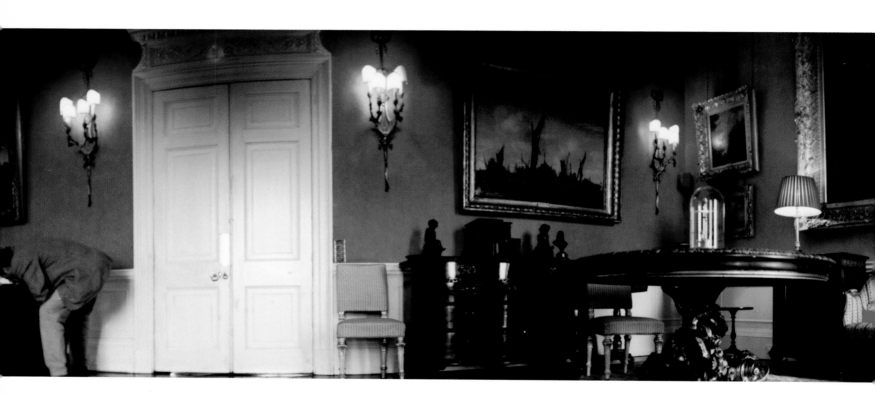

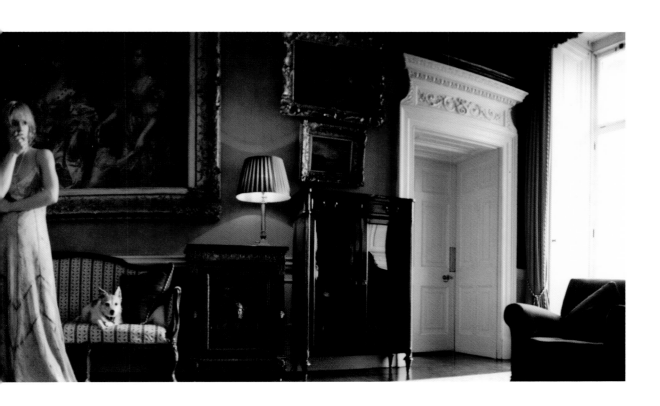

Knackered 1996
16 mm with sound 3 mins. 5 secs.

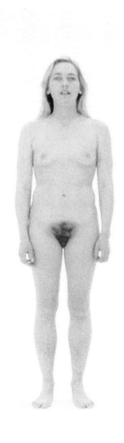

Five Revolutionary Seconds IV 1996
Colour photograph on vinyl with sound 72 x 757 cm

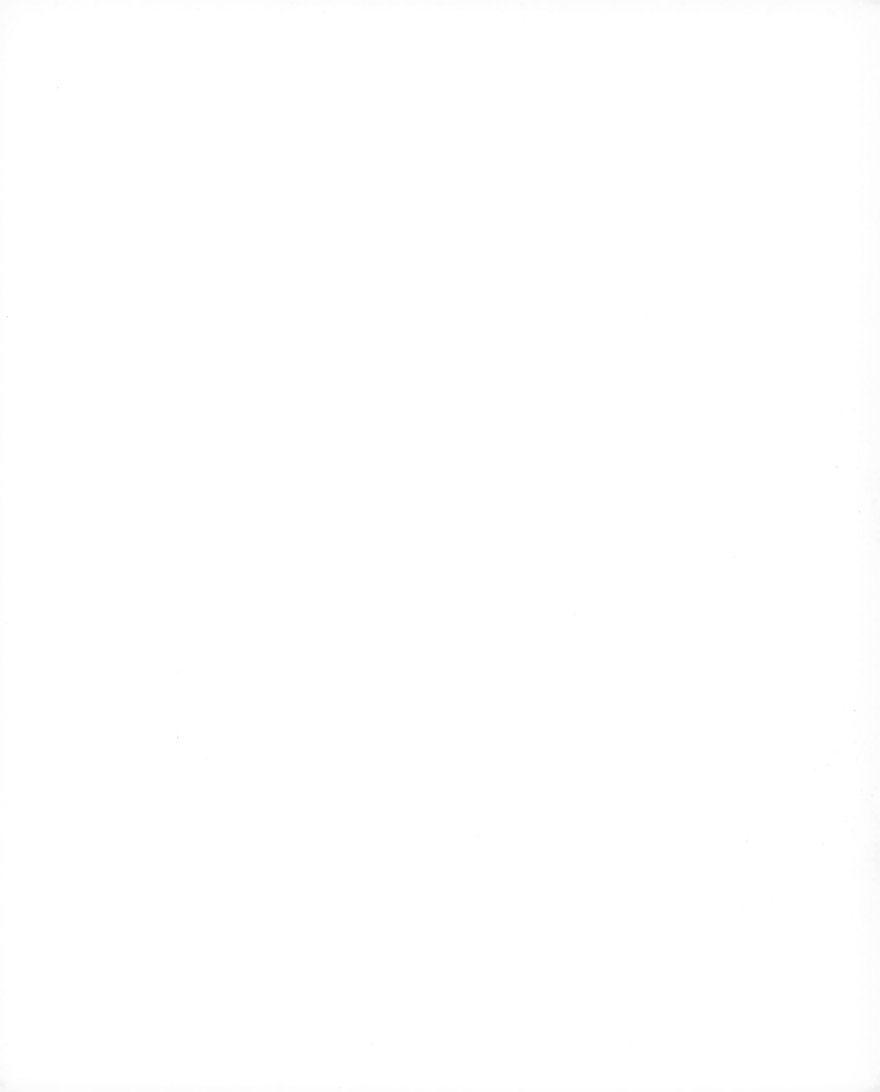

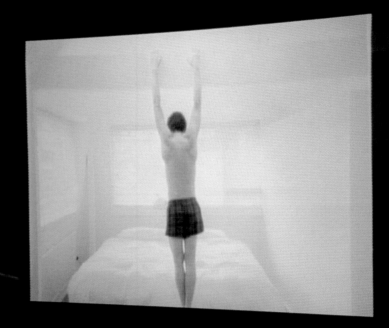

Pent-Up 1996
16 mm with sound 10 mins. 30 secs.

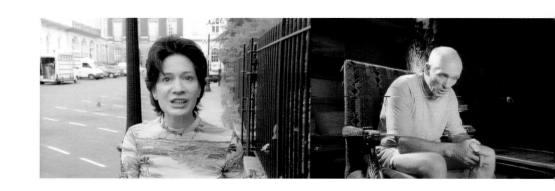

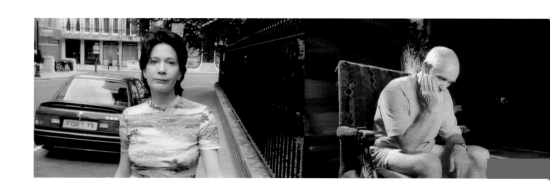

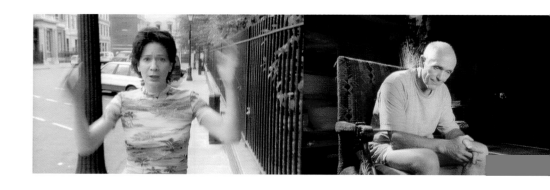

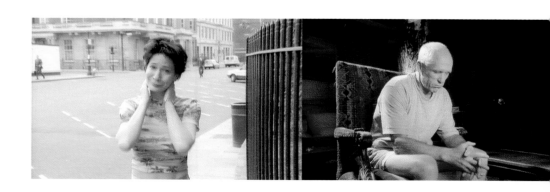

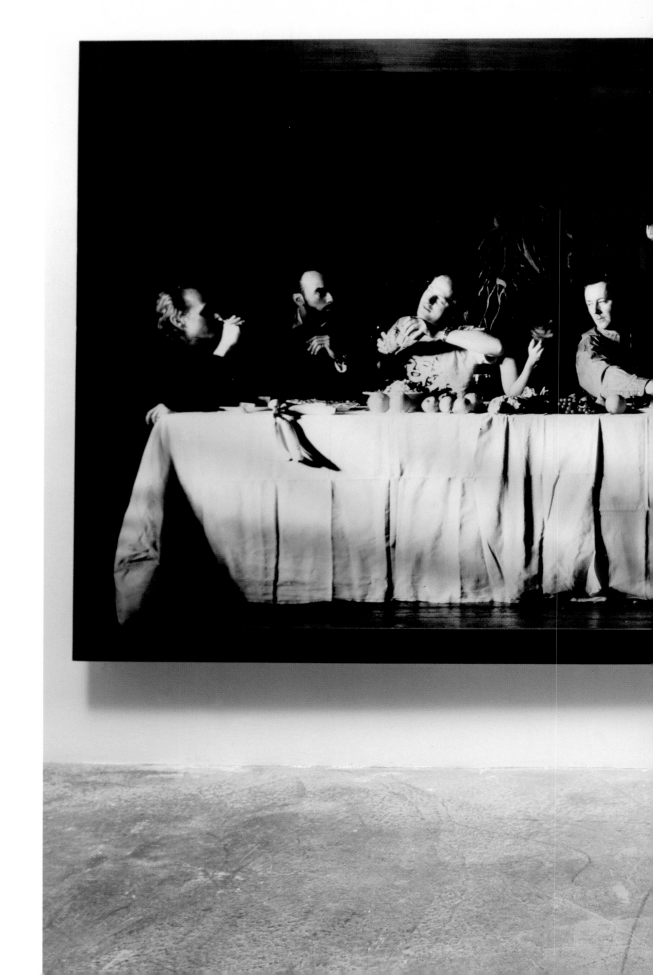

Wrecked 1996
C-type colour print 152.4 x 396.2 cm

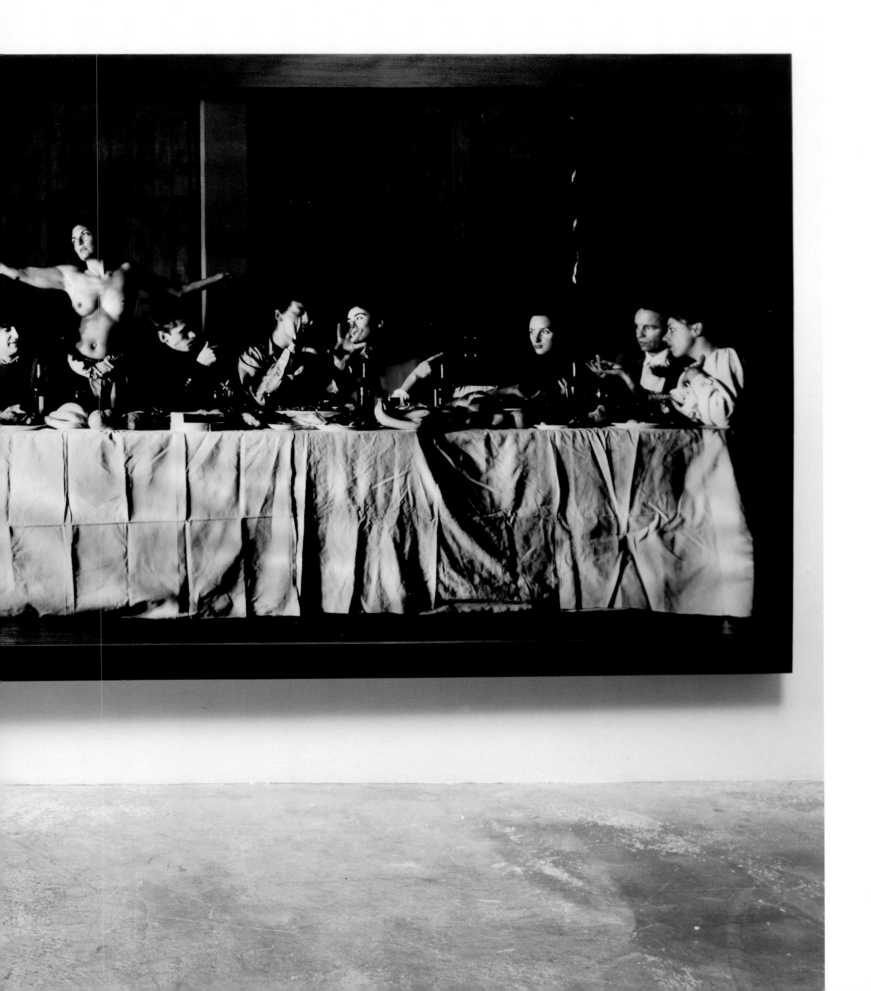

Five Revolutionary Seconds V 1996
Colour photograph on vinyl with sound 72 x 757 cm

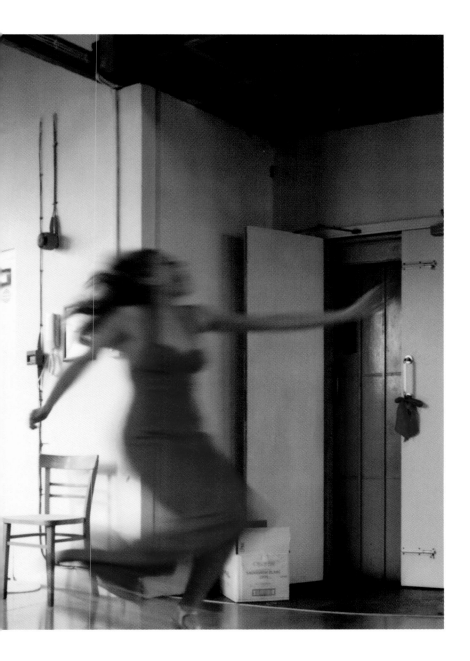

Five Revolutionary Seconds VI 1996
Colour photograph on vinyl with sound 72 x 757 cm

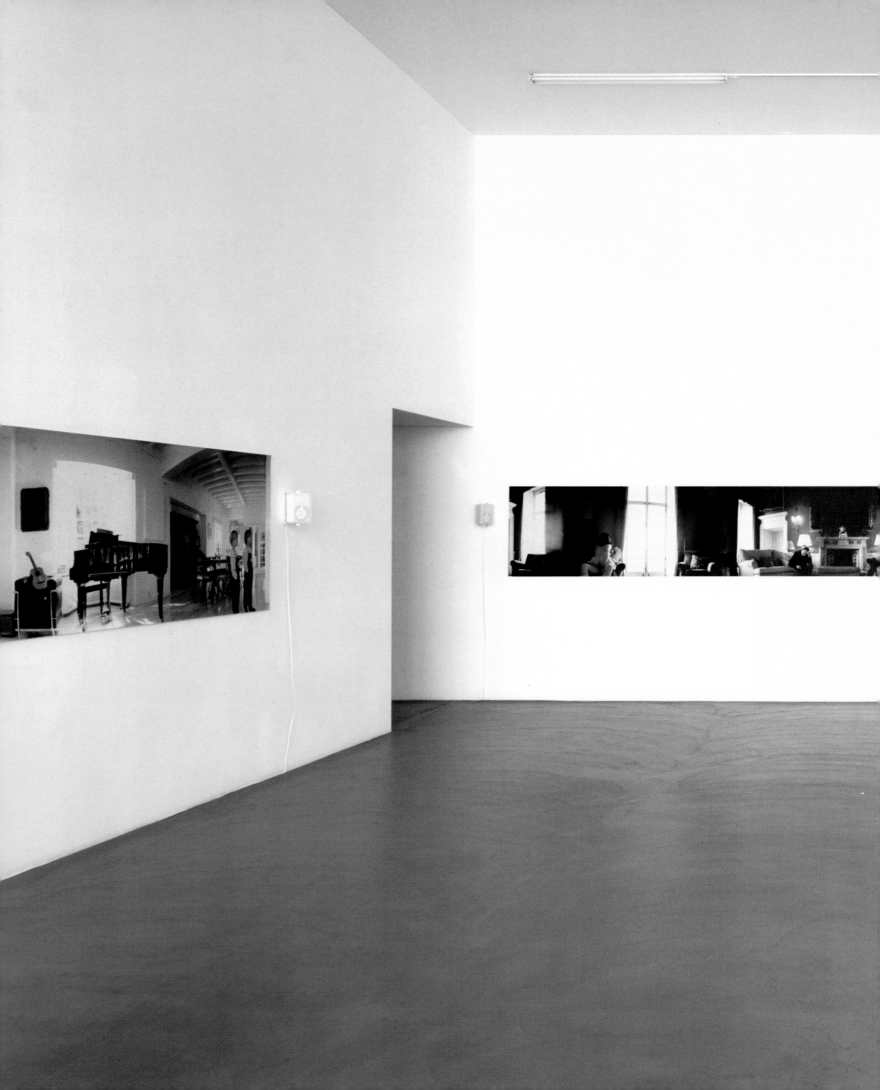

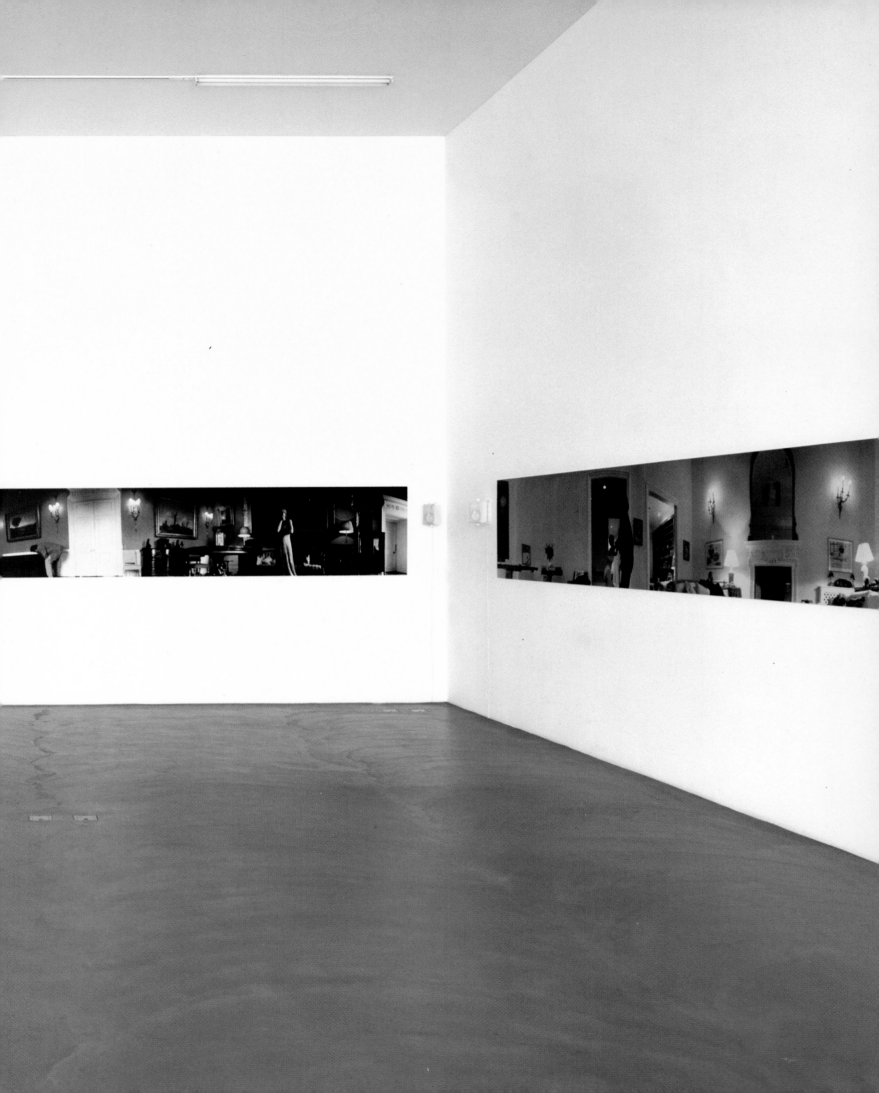

1997

Five Revolutionary Seconds VII 1997
Colour photograph on vinyl with sound 118 x 791 cm

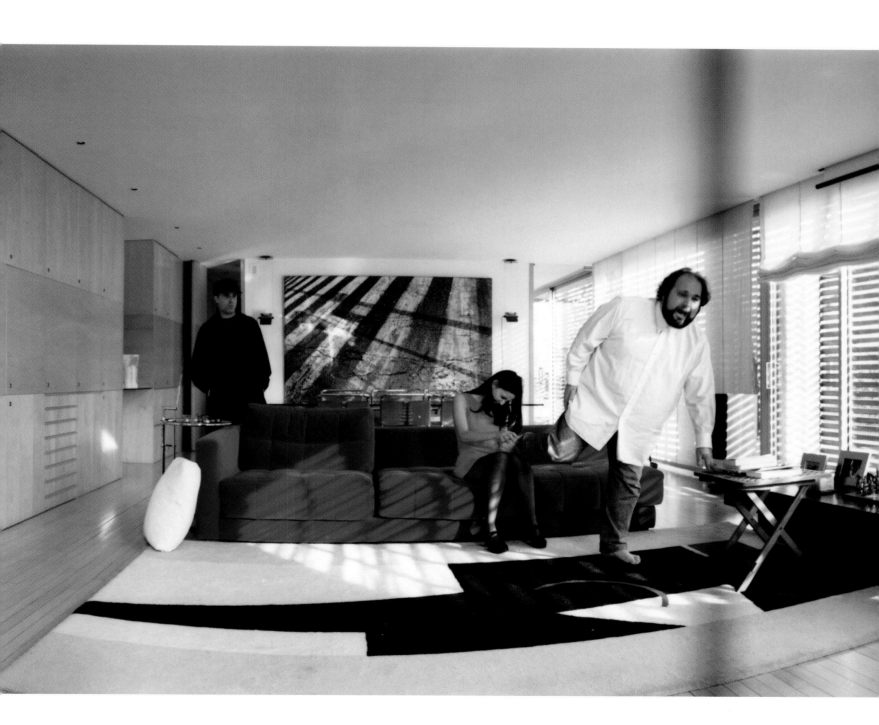

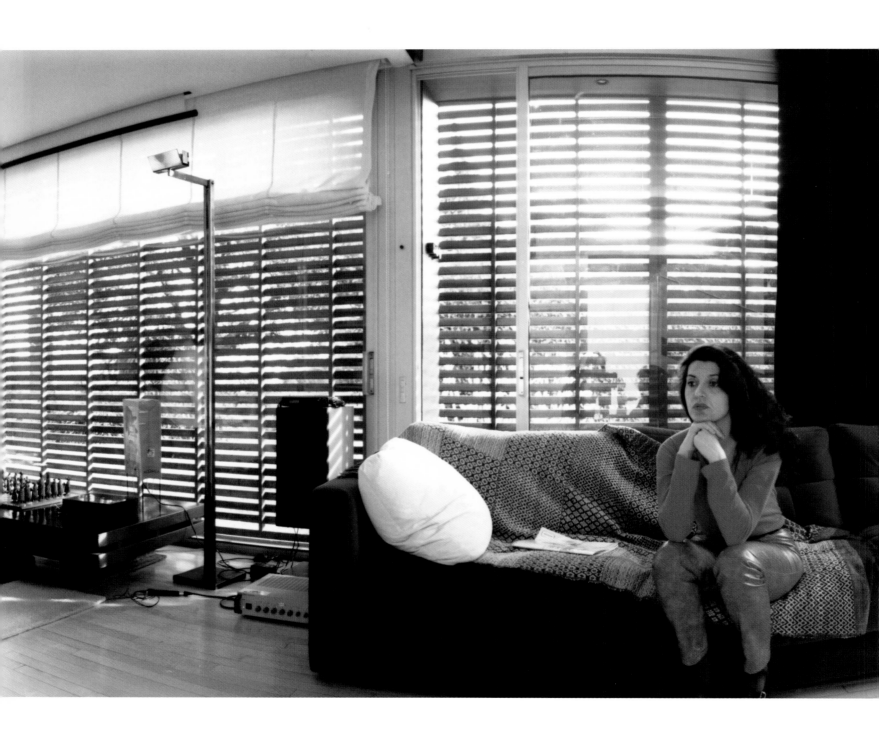

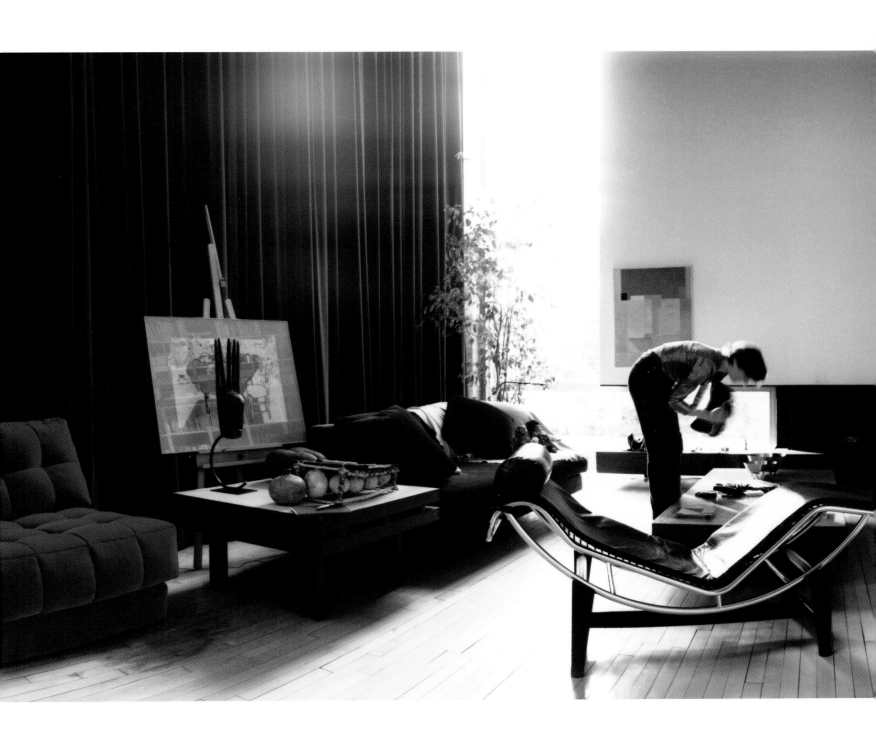

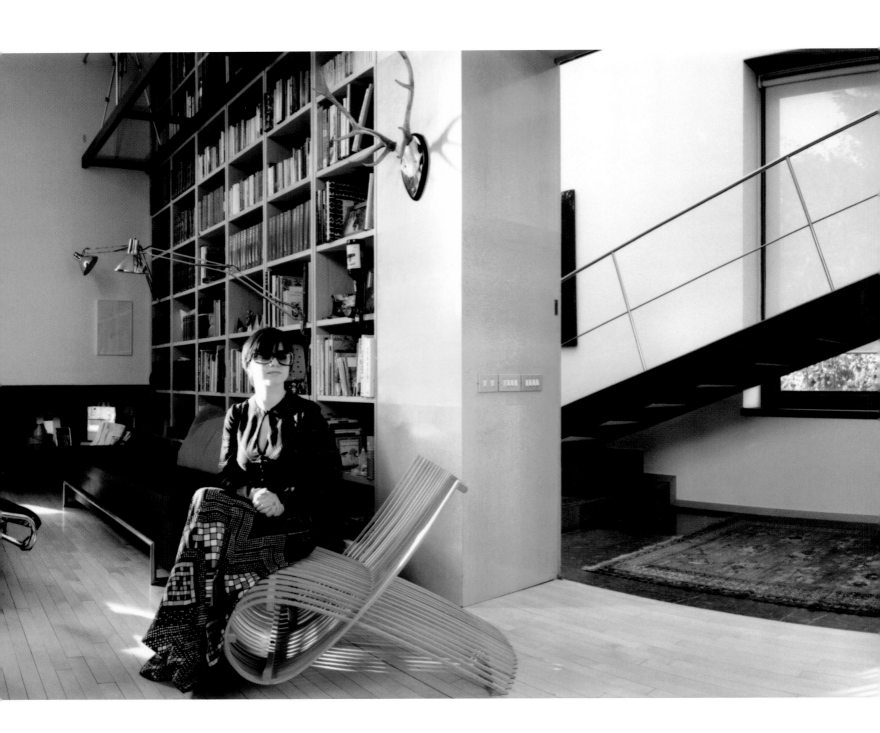

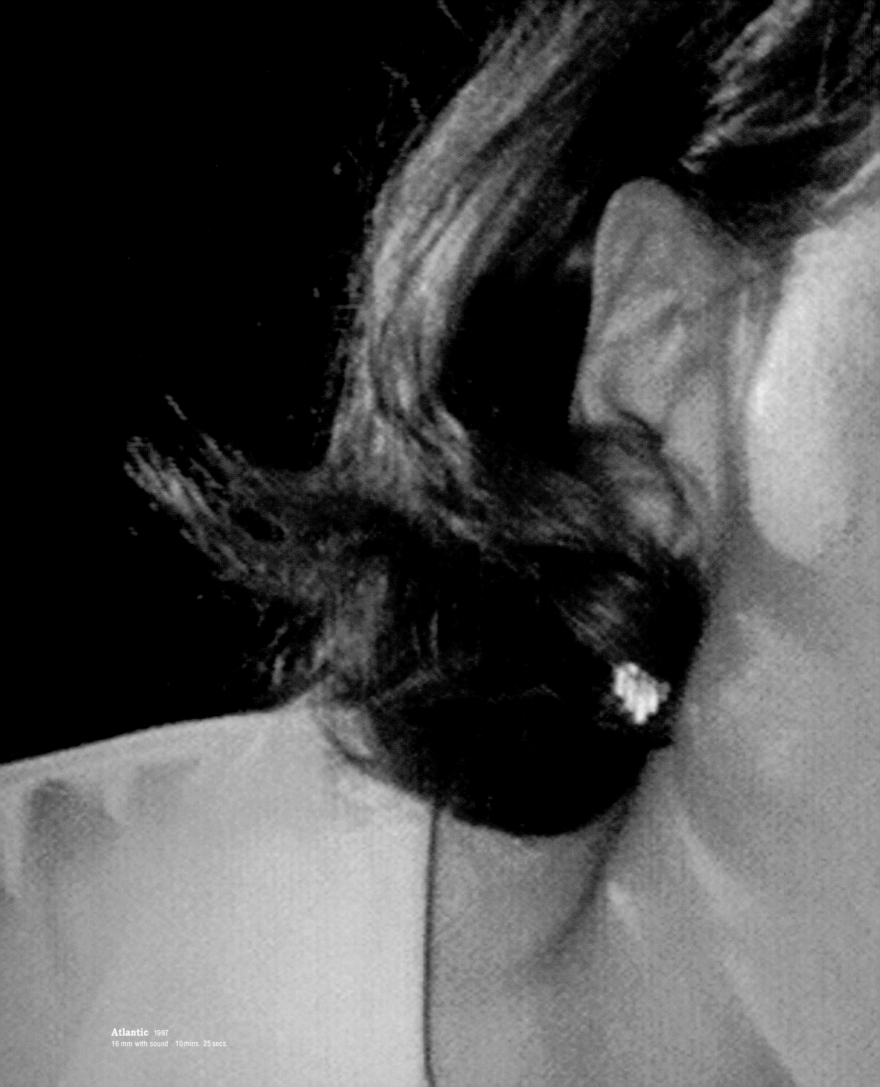

Atlantic 1997
16 mm with sound 10 mins. 25 secs.

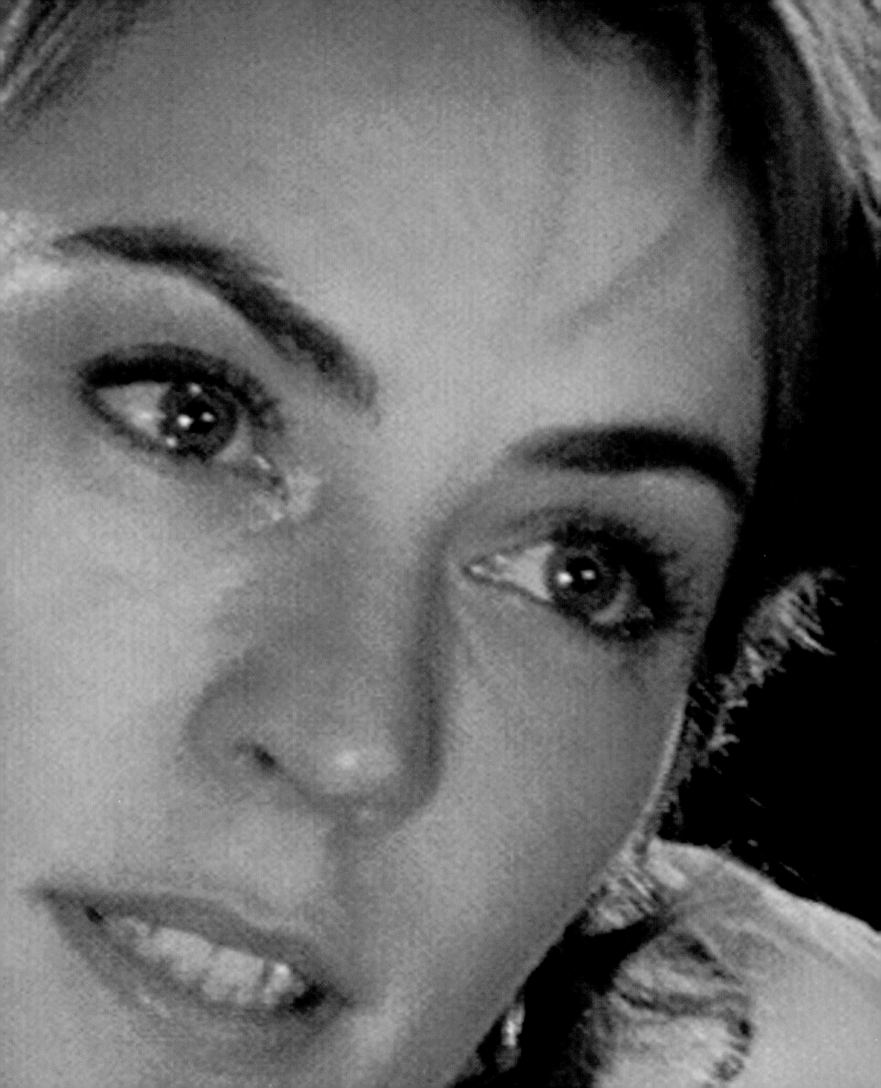

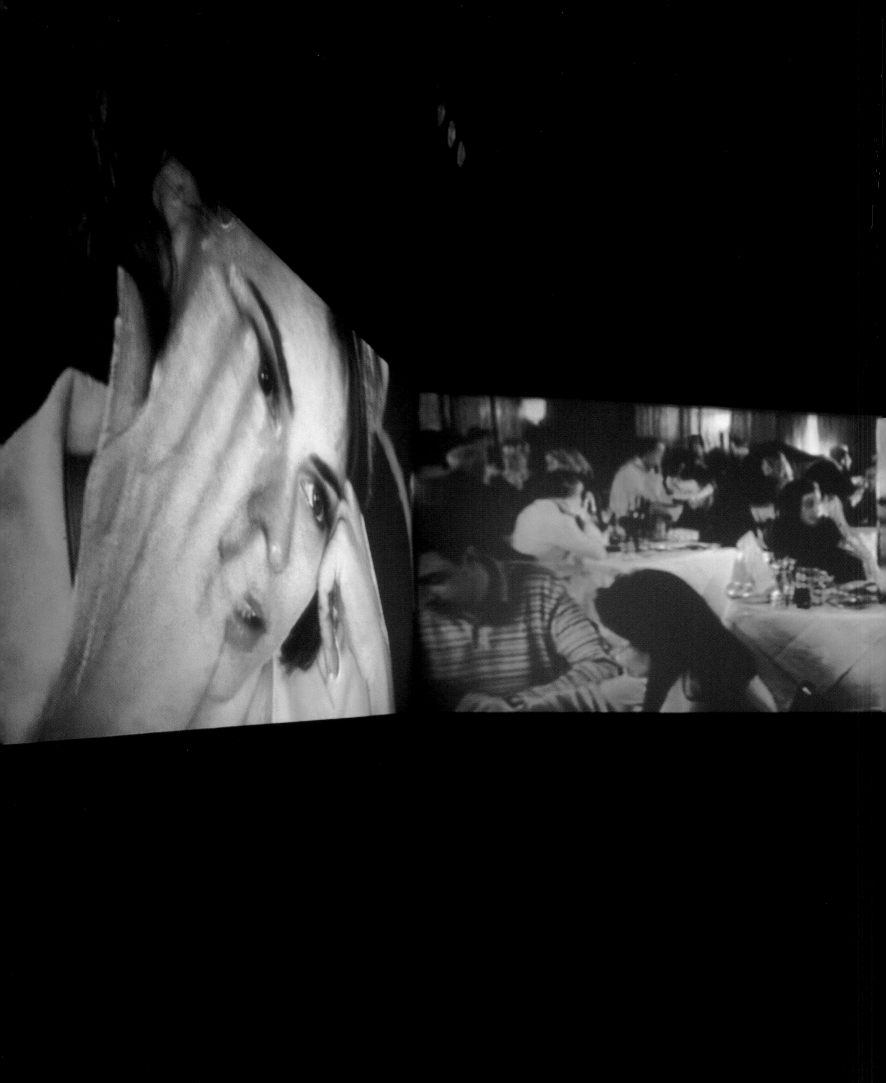

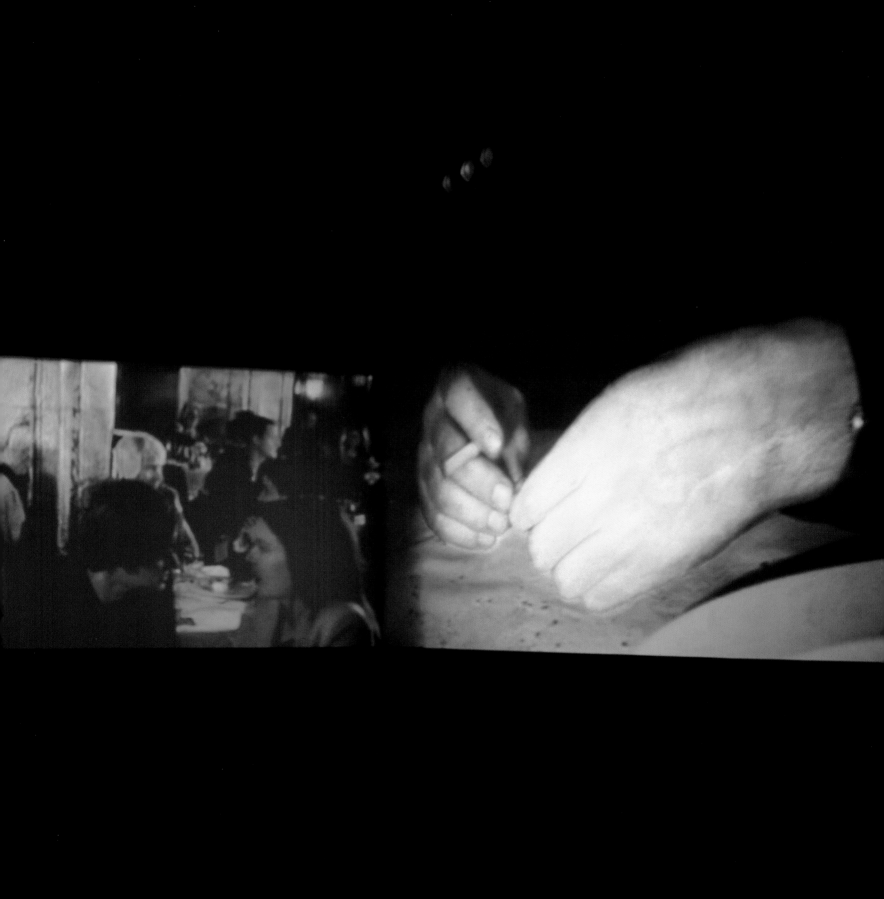

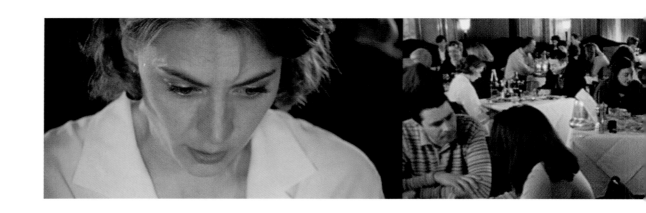

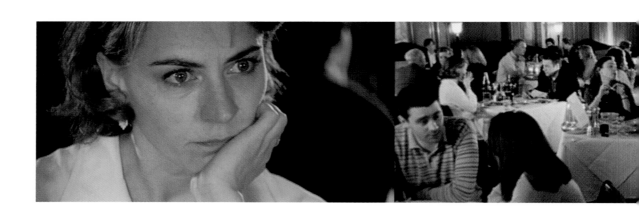

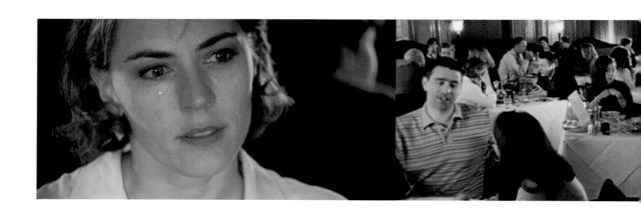

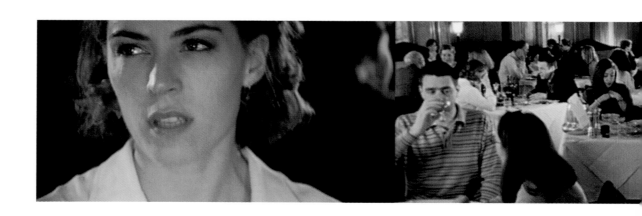

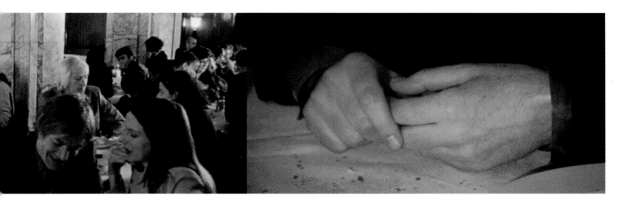

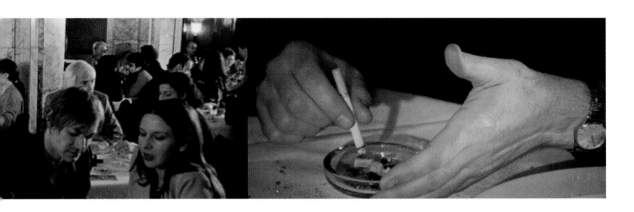

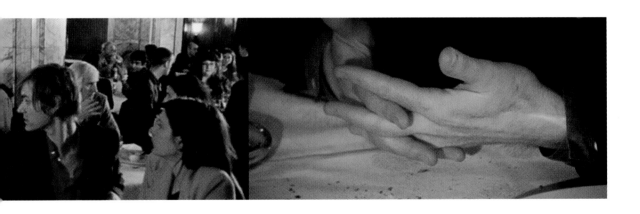

Five Revolutionary Seconds VIII 1997
Colour photograph on vinyl with sound 106 x 764 cm

Five Revolutionary Seconds IX 1997
Colour photograph on vinyl with sound 109 x 777 cm

Five Revolutionary Seconds X 1997
Colour photograph on vinyl with sound 106 x 757 cm

Five Revolutionary Seconds XI 1997
Colour photograph on vinyl with sound 72 x 757 cm

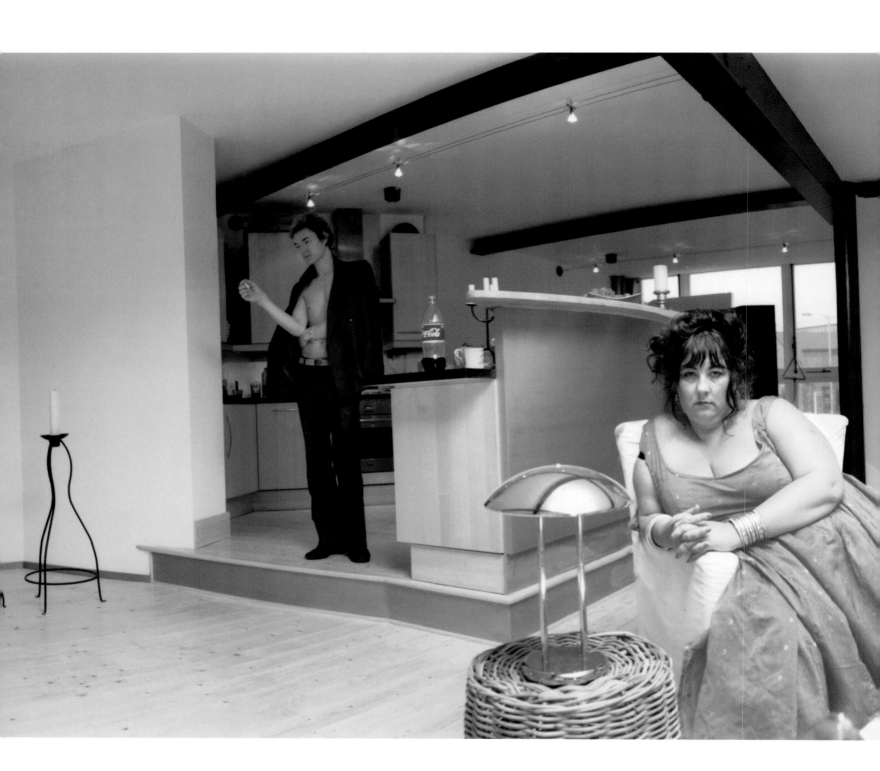

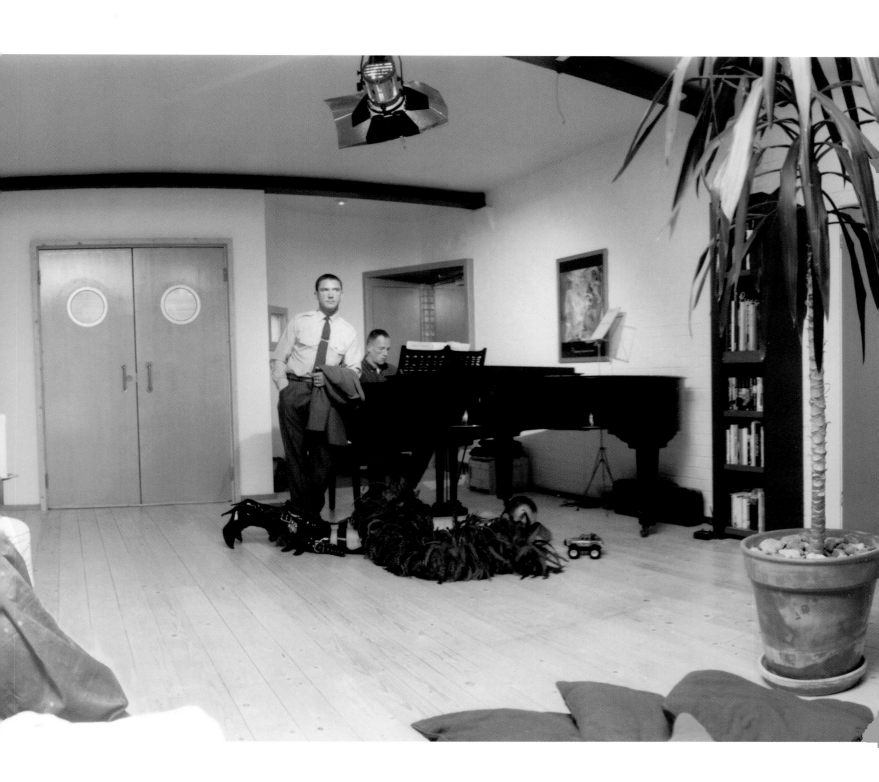

Hysteria 1997
16 mm 8 mins.

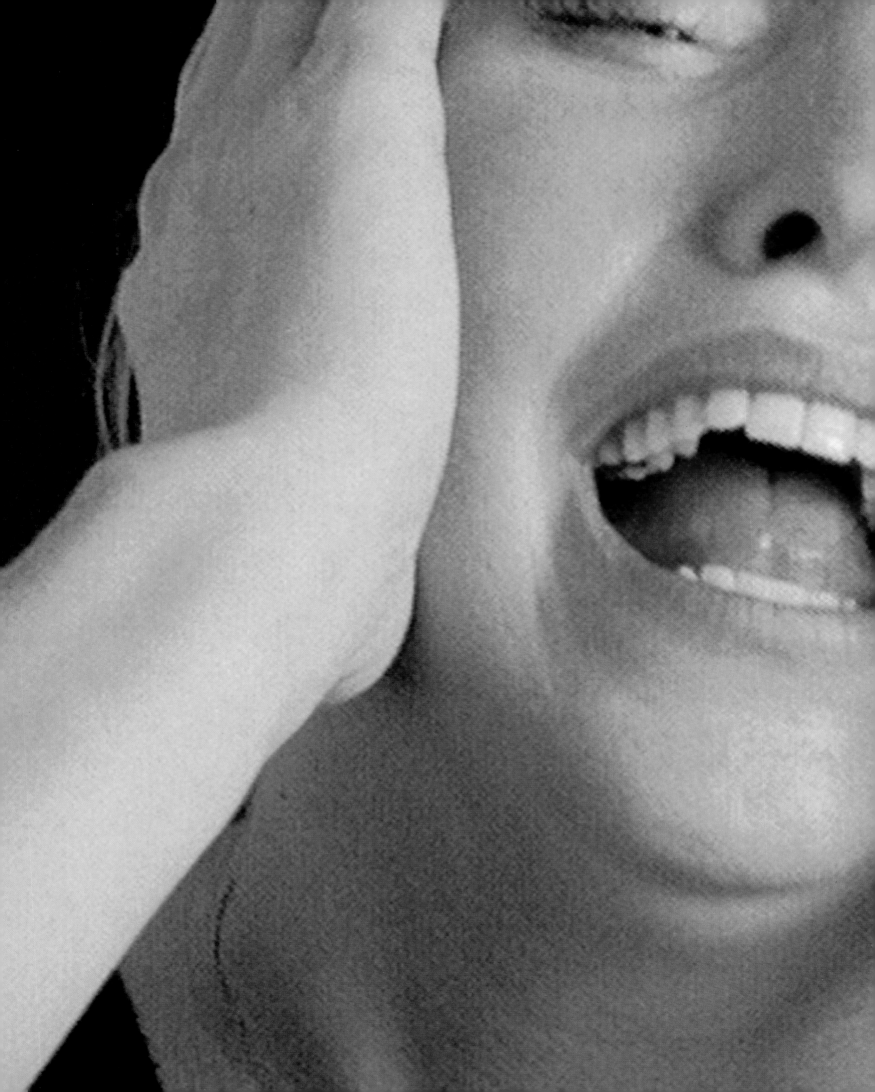

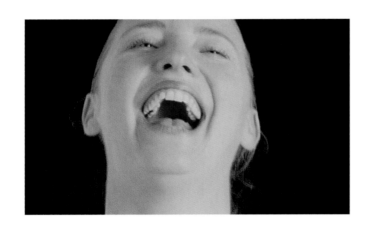
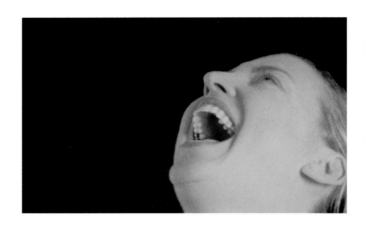
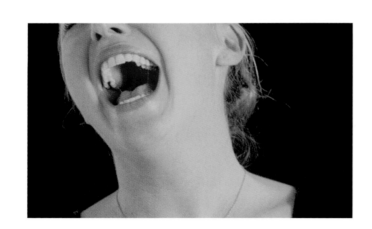
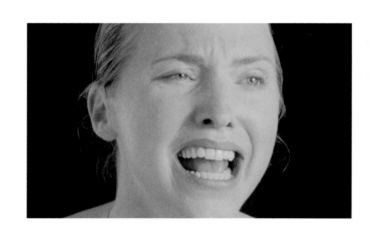
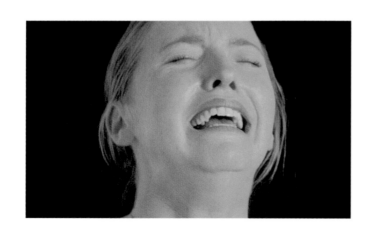
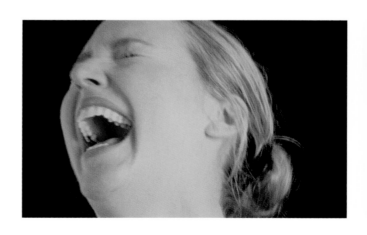

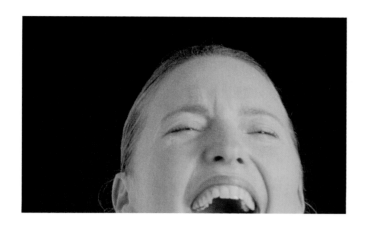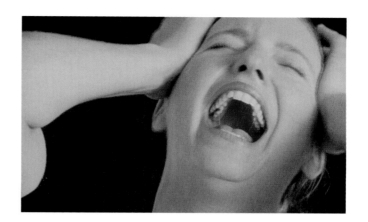
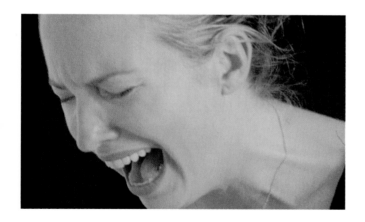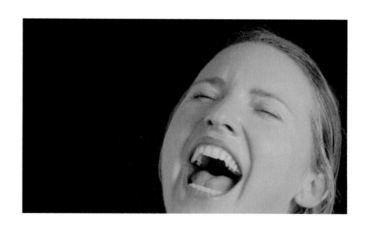
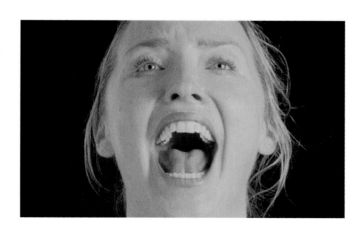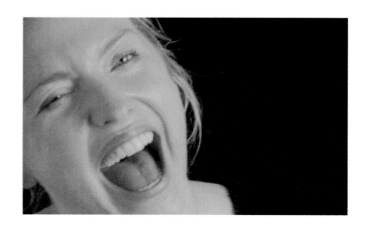

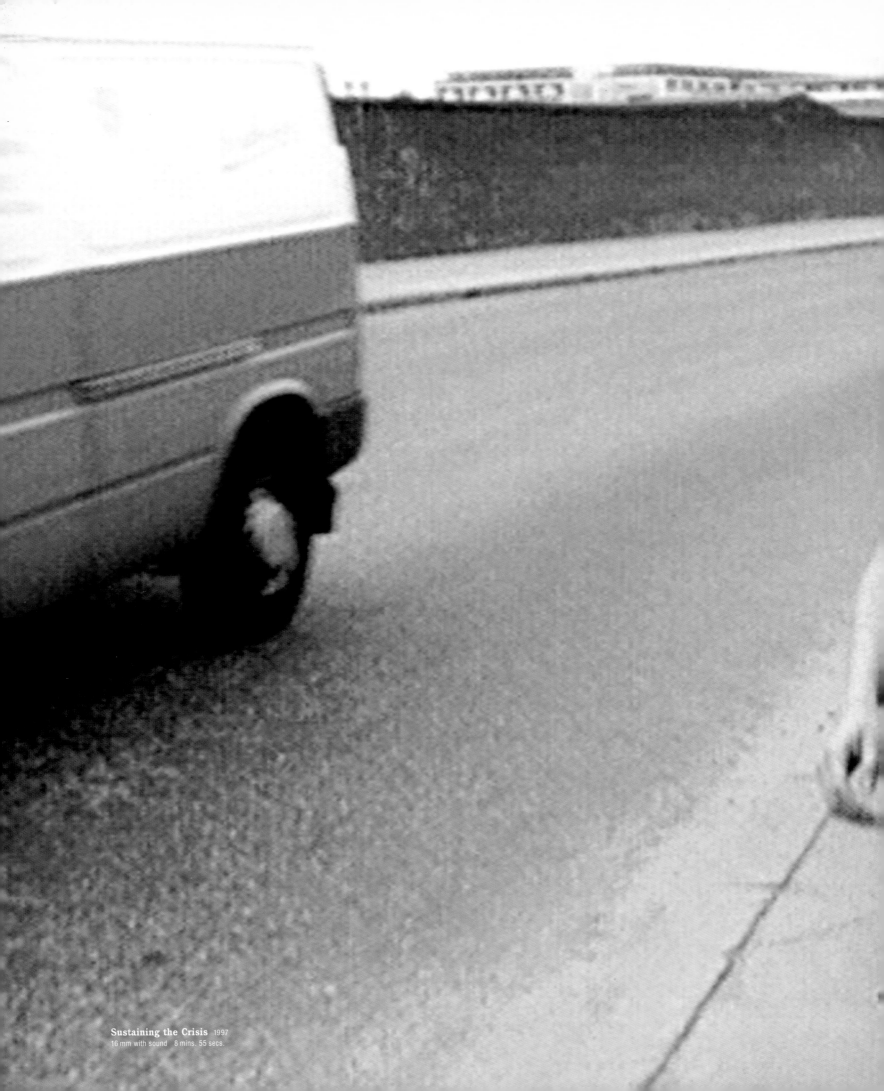

Sustaining the Crisis 1997
16 mm with sound 8 mins. 55 secs.

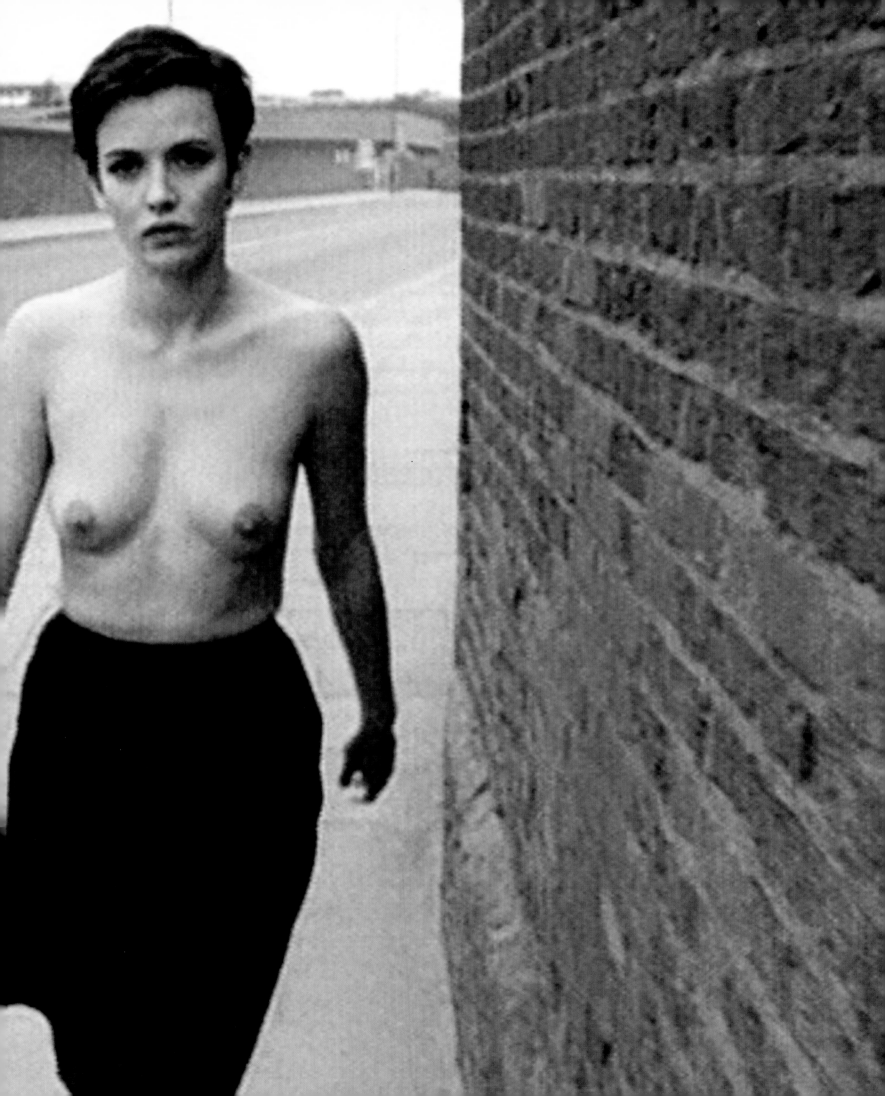

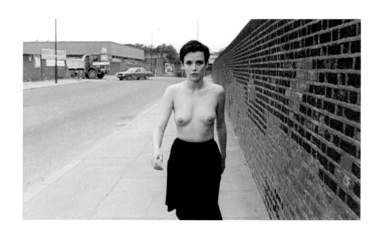 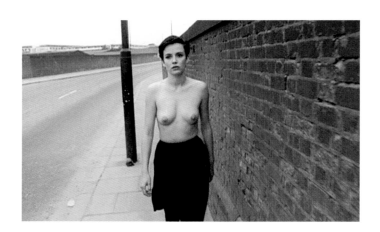

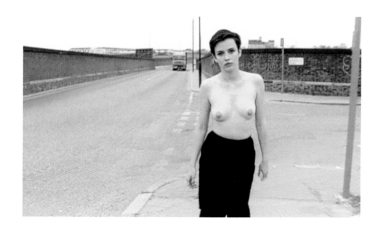 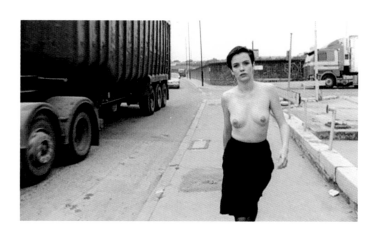

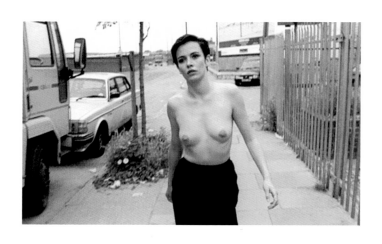 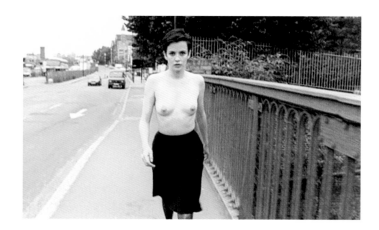

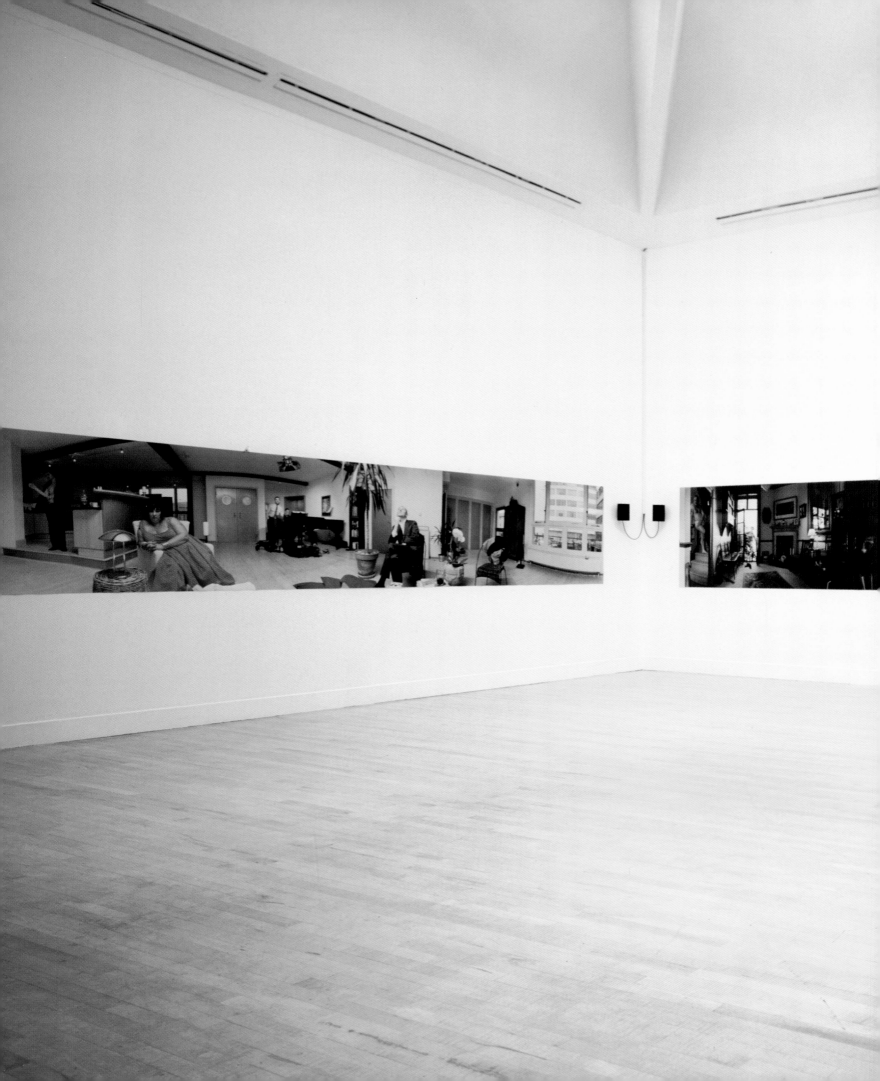

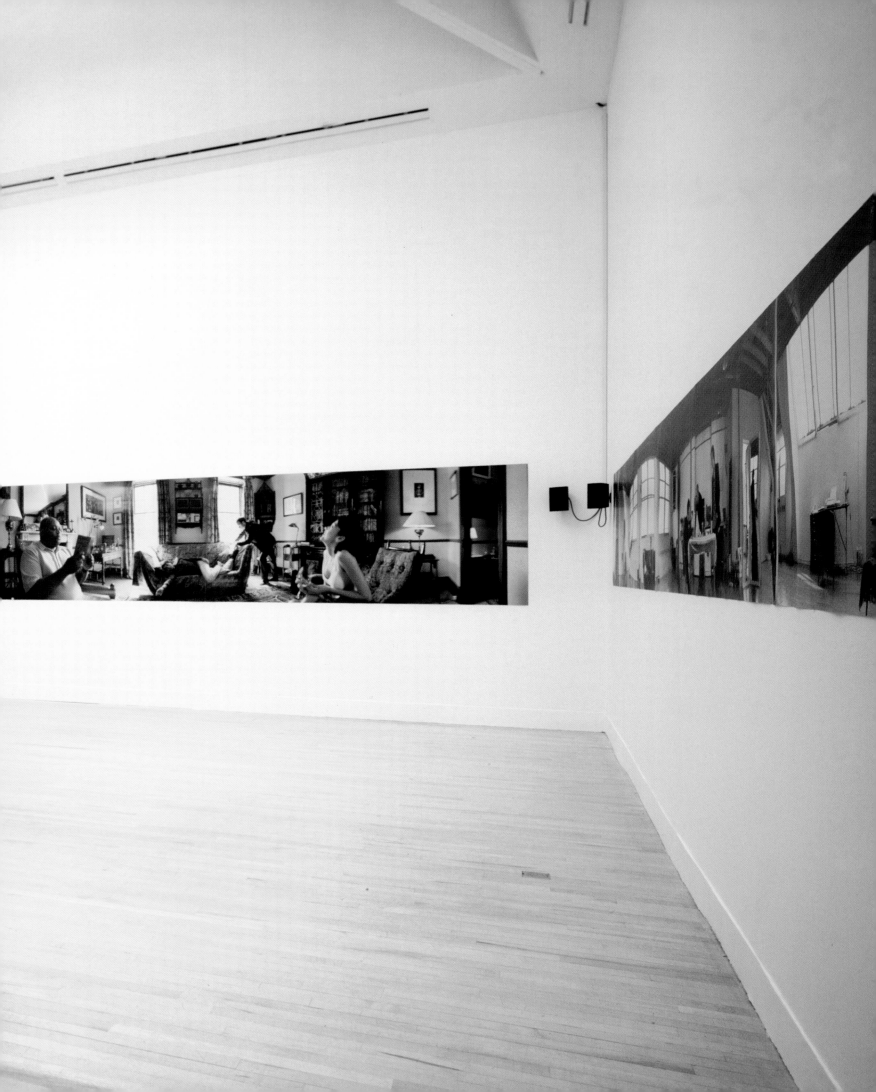

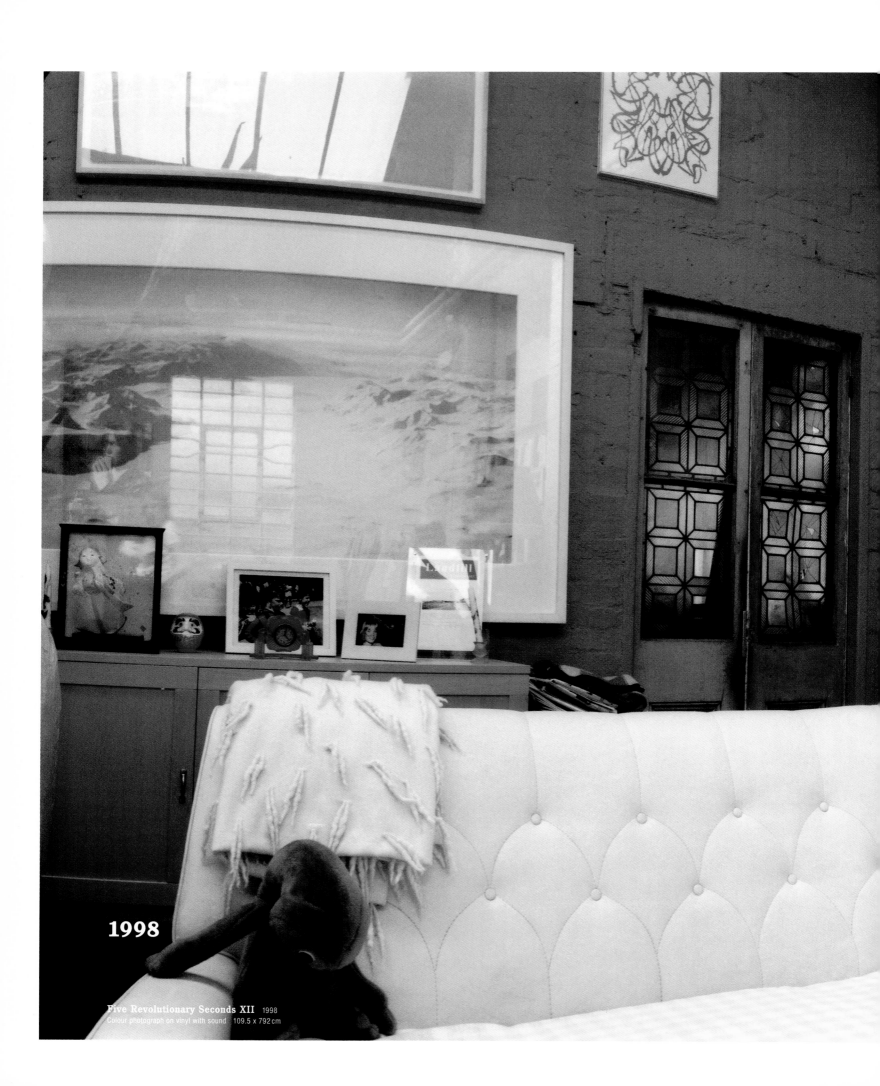

1998

Five Revolutionary Seconds XII 1998
Colour photograph on vinyl with sound 109.5 x 792 cm

Five Revolutionary Seconds XIII 1998
Colour photograph on vinyl with sound 113.7 x 775 cm

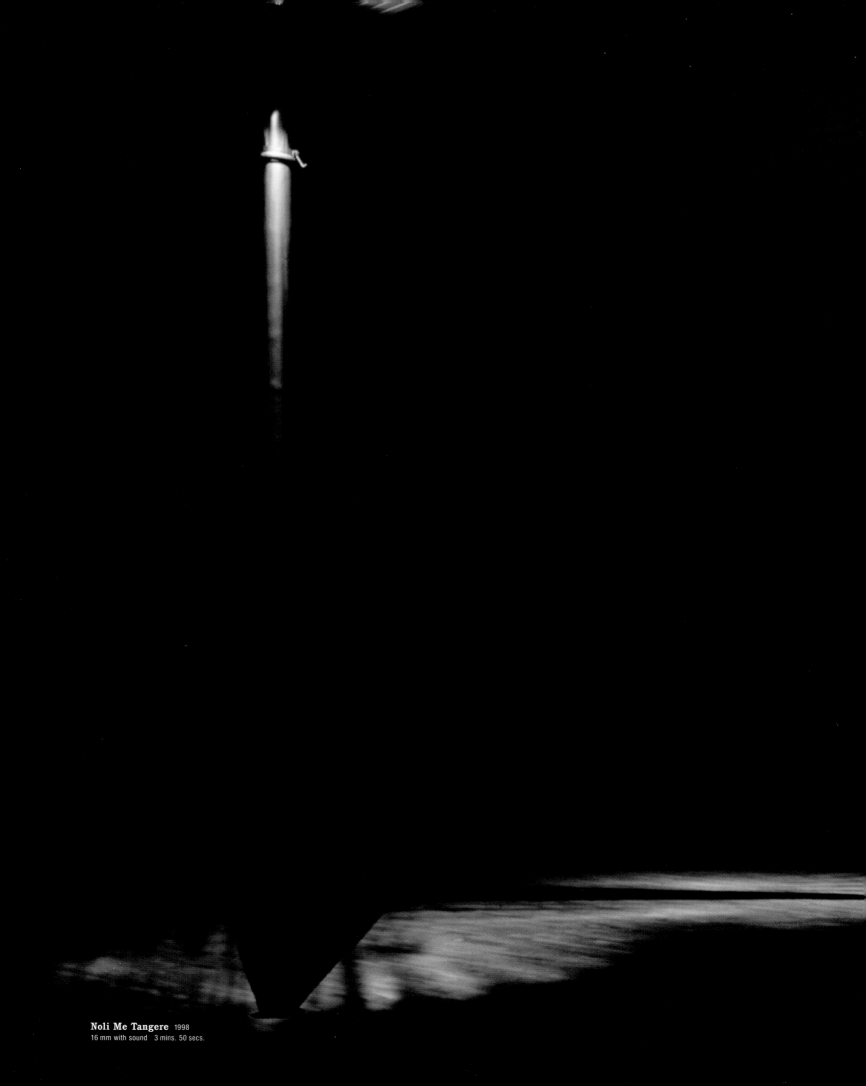

Noli Me Tangere 1998
16 mm with sound 3 mins. 50 secs.

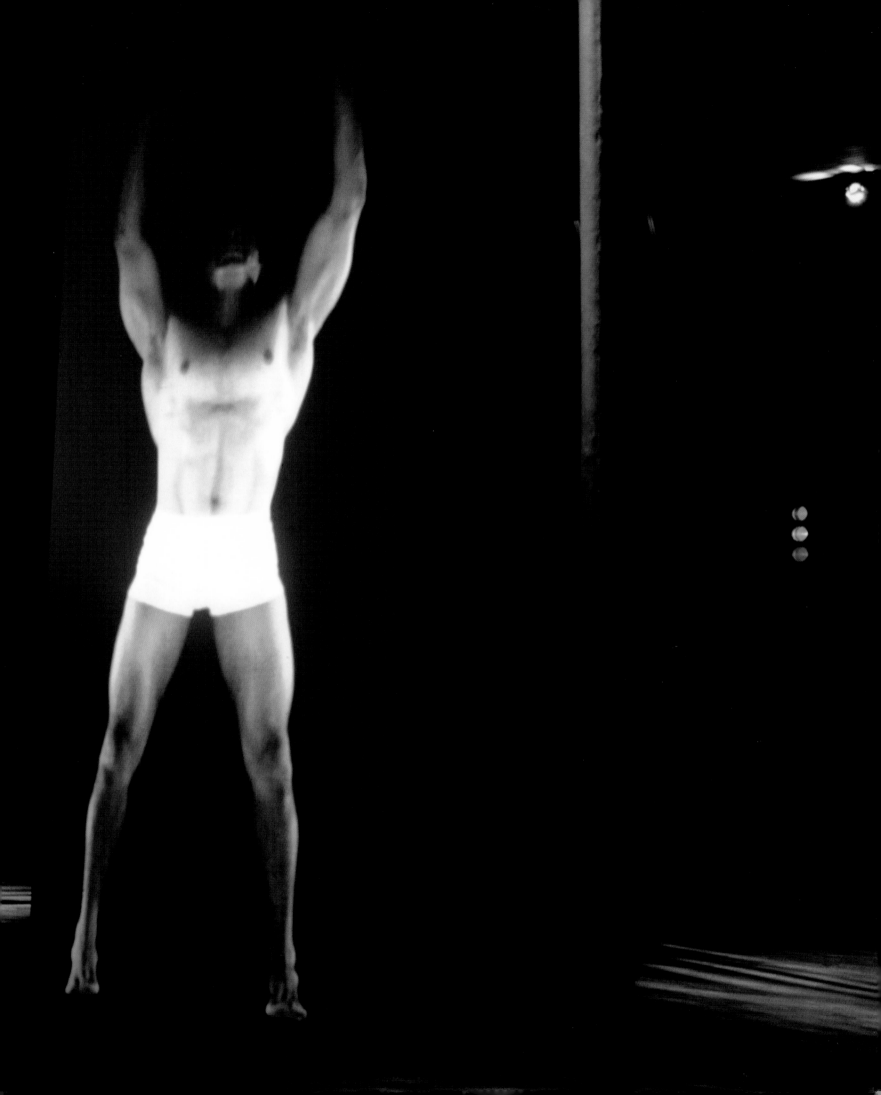

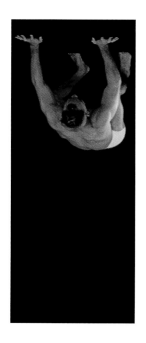

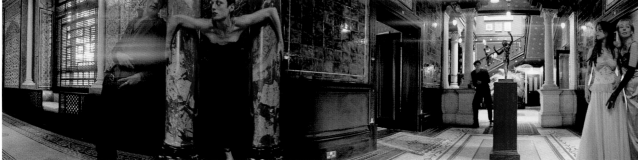

Soliloquy I 1998
C-type print 211 x 257 cm

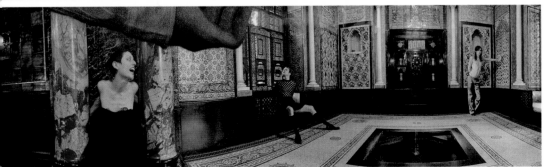

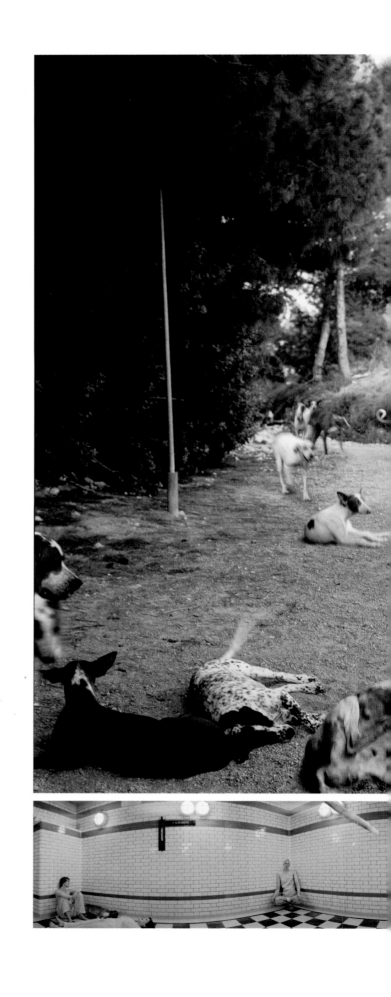

Soliloquy II 1998
C-type print 207 x 257 cm

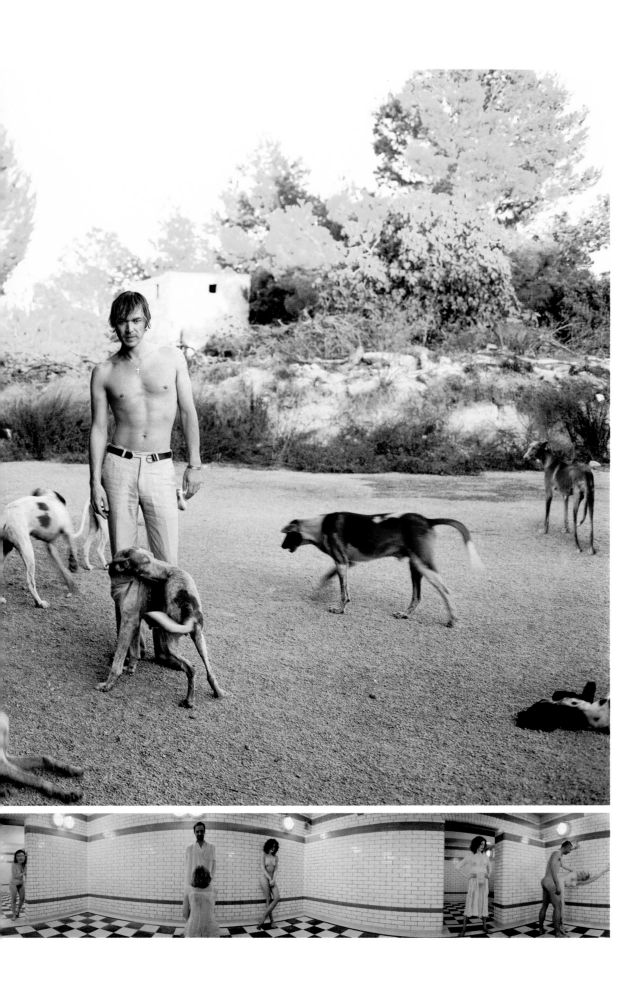

Soliloquy III 1998
C-type print 227 x 257 cm

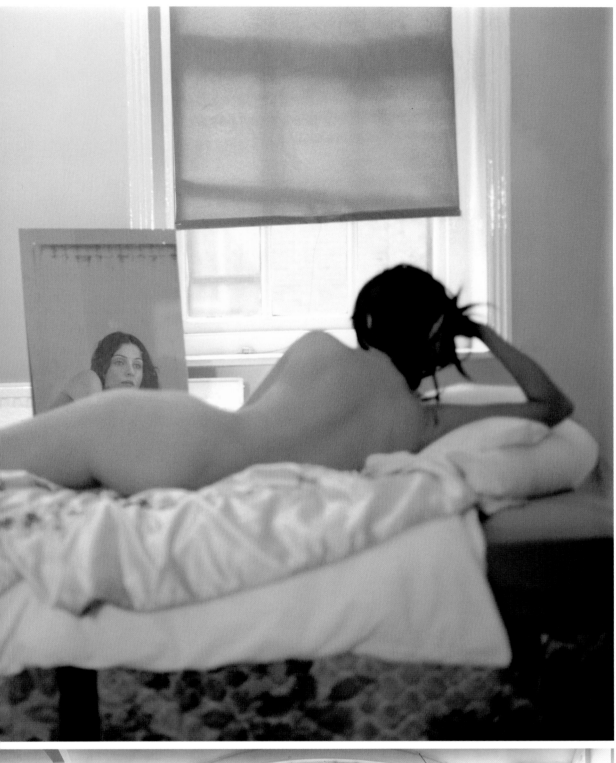

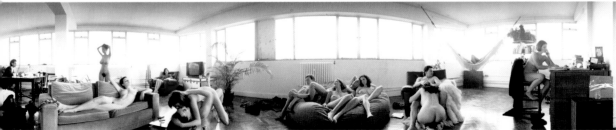

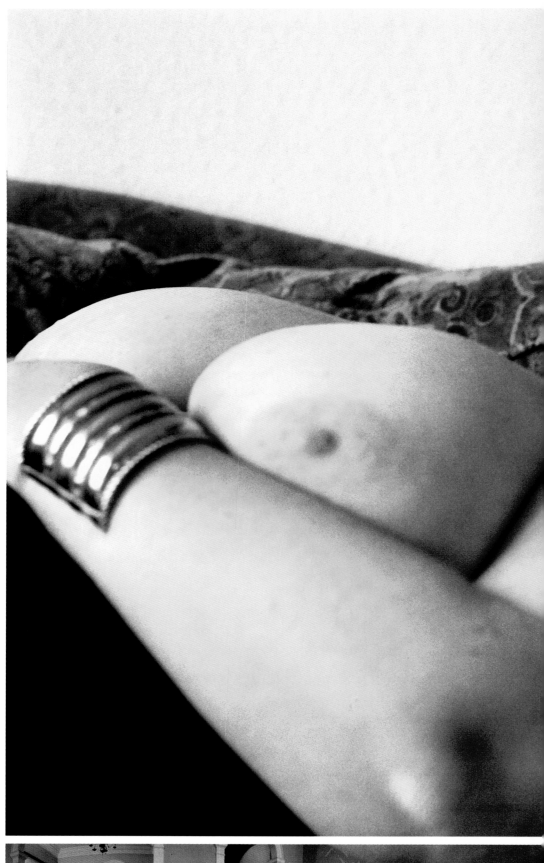

Soliloquy IV 1998
C-type print 222 x 257 cm

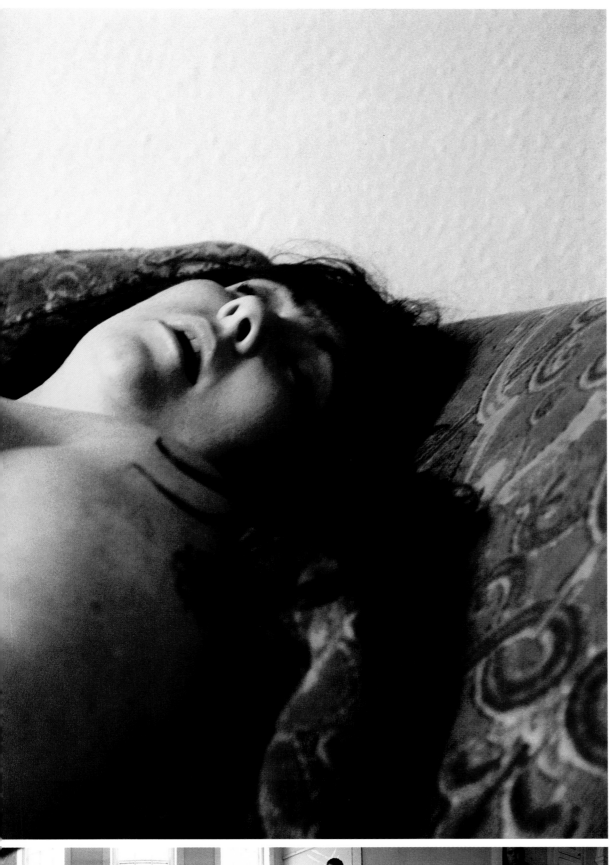

1999

Five Revolutionary Seconds XIV 1999
Colour photograph on vinyl with sound 106 x 761 cm

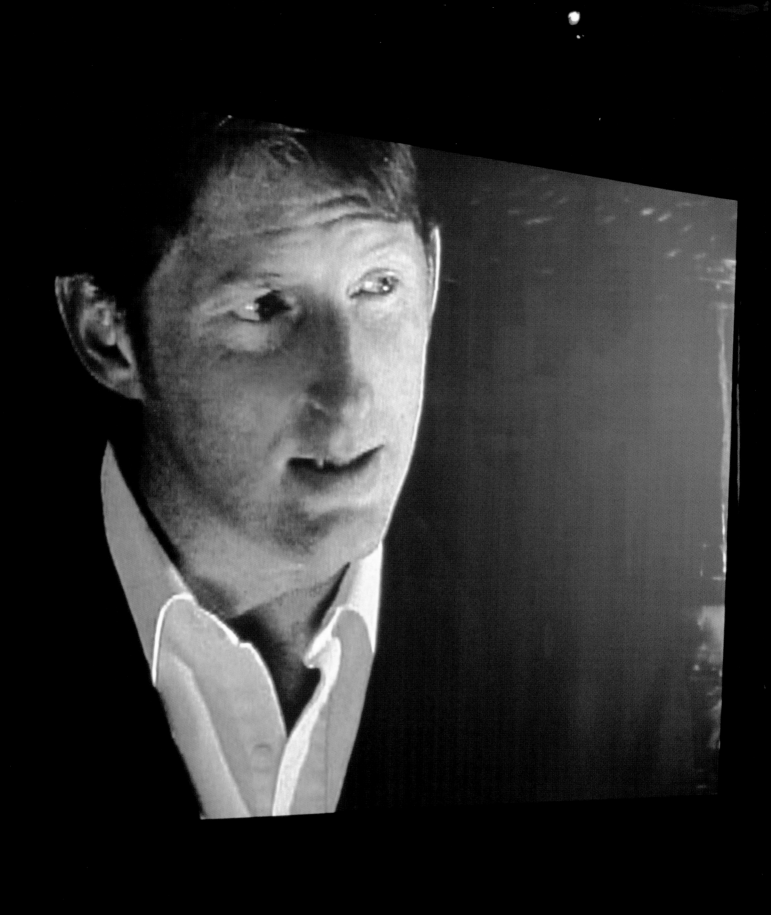

Third Party 1999
16 mm with sound 10 mins.

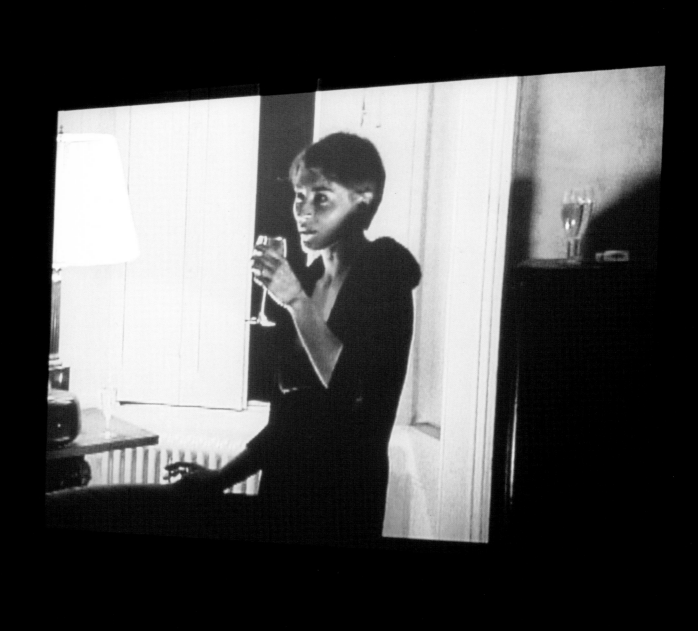

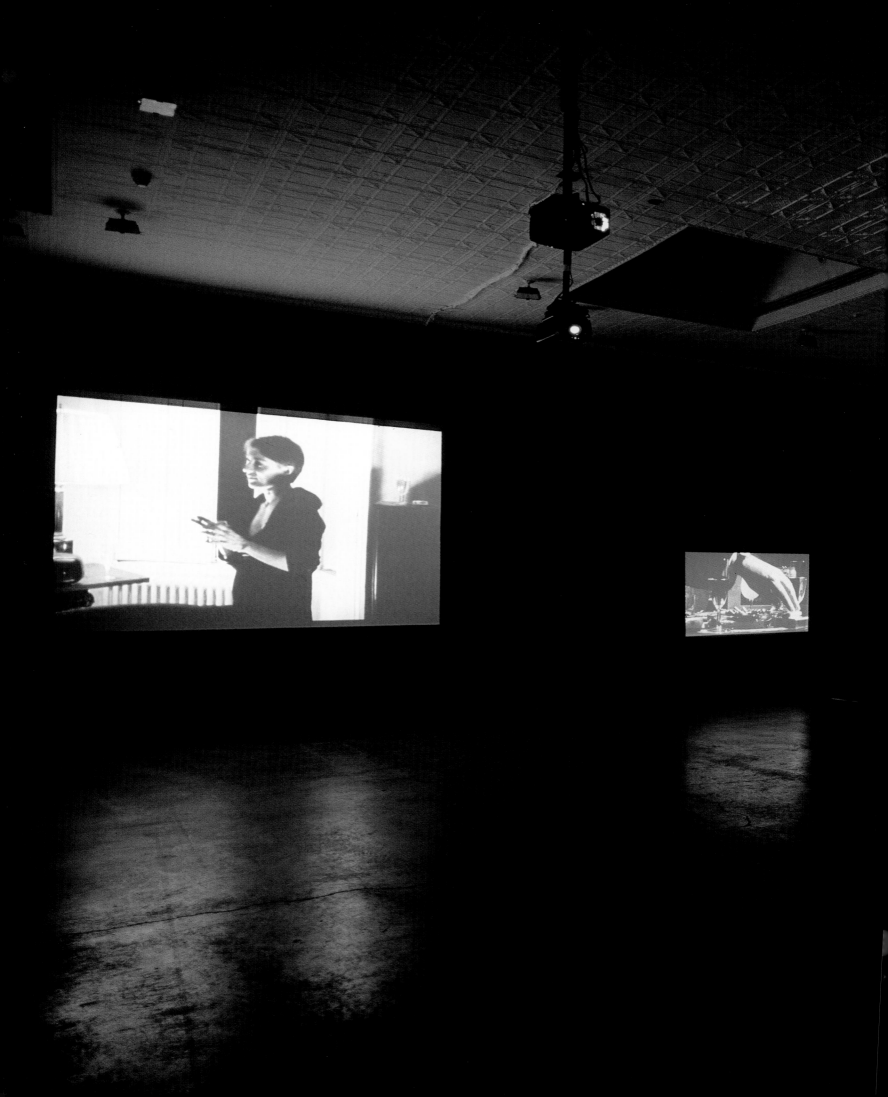

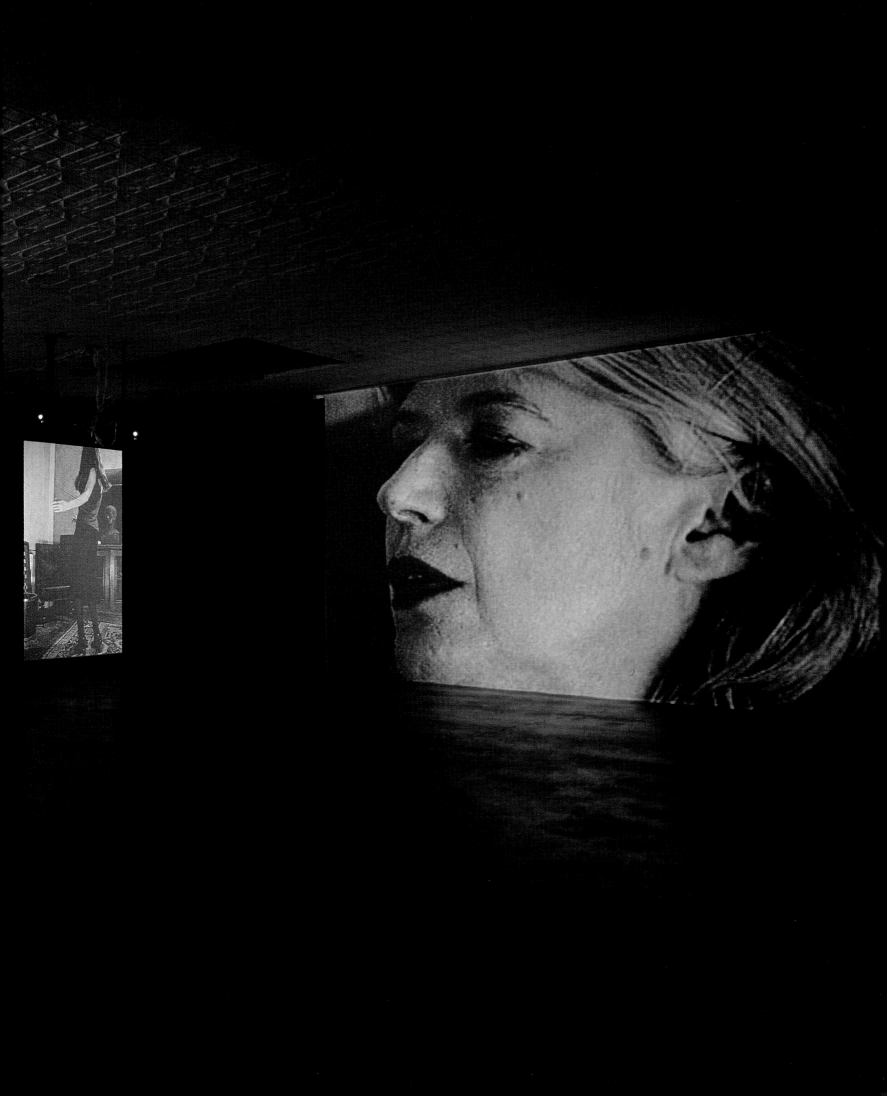

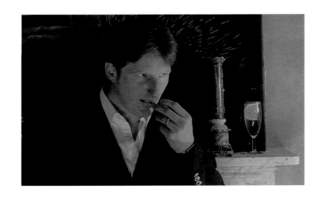
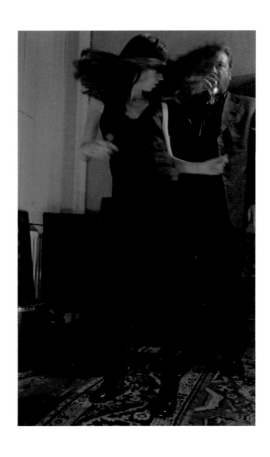

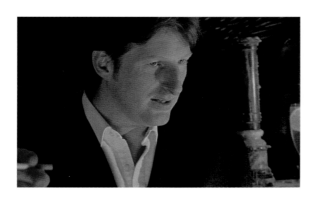
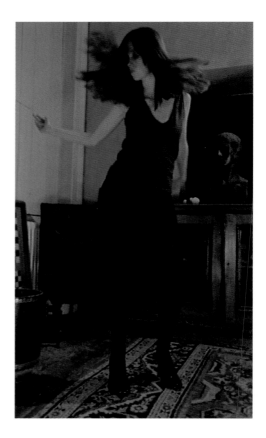
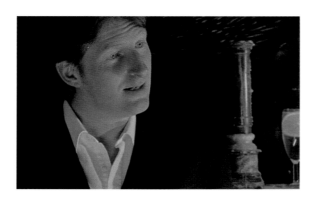

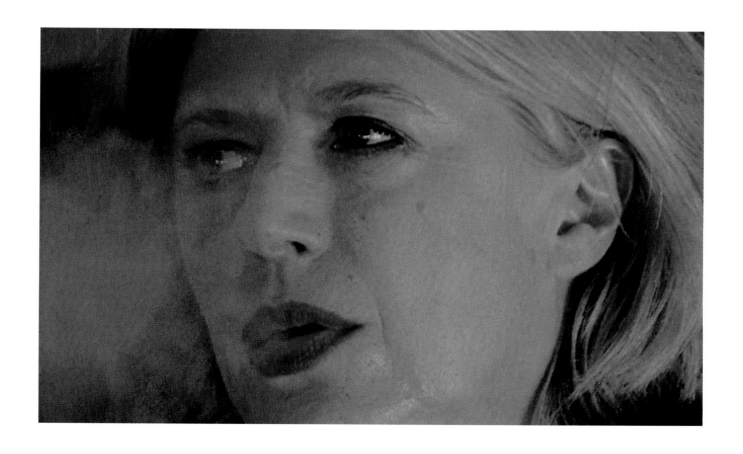

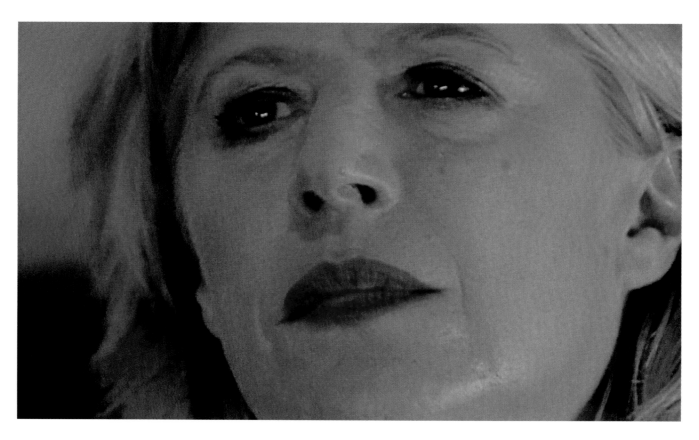

2000

XV Seconds (after Ingres) 2000
C-type print 125 x 84 cm

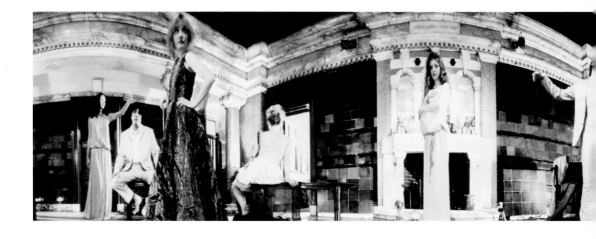

XV Seconds 2000
Lambda print 27 x 212 cm

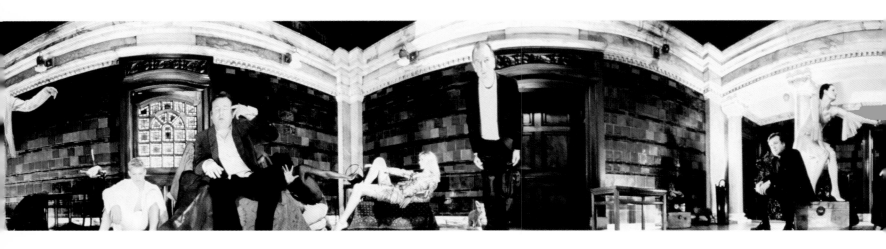

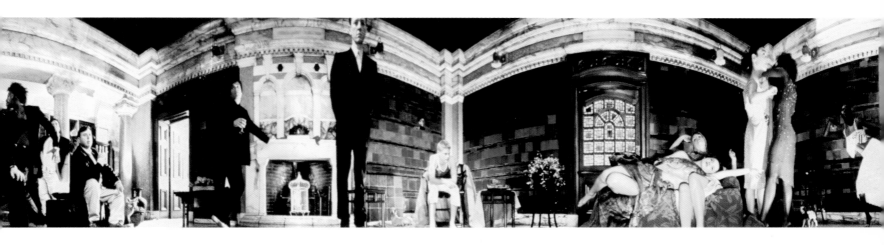

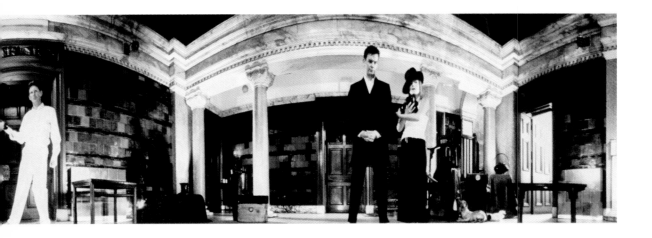

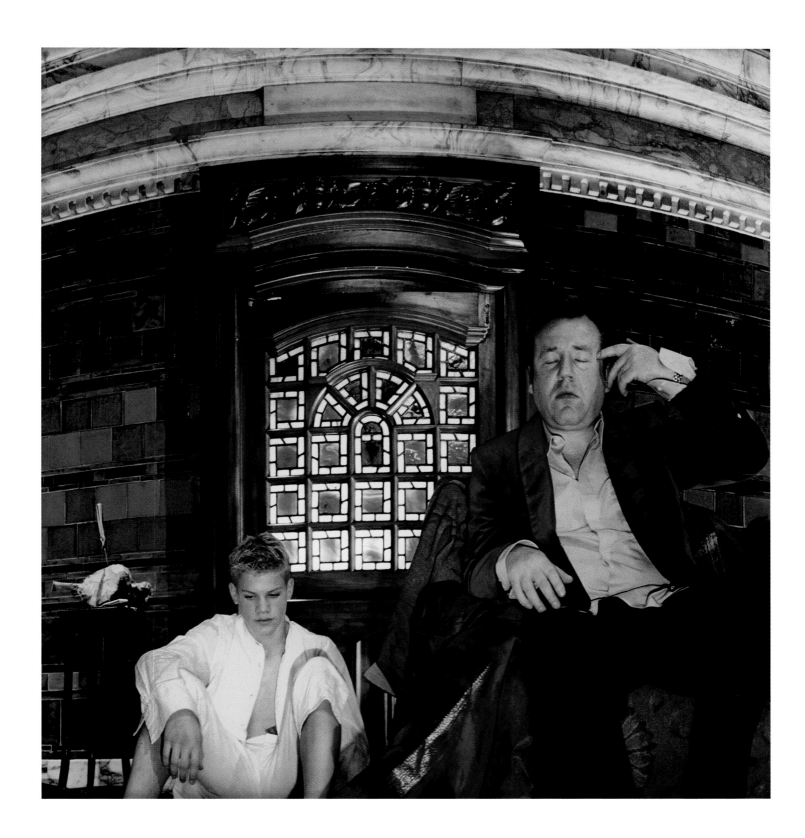

XV Seconds (after Scorsese) 2000
C-type print 125 x 123 cm

Five Revolutionary Seconds XV 2000
Colour photograph on vinyl with sound 109.5 x 792 cm

Self Portrait as a Tree 2000
C-type print 75.6 x 91 cm

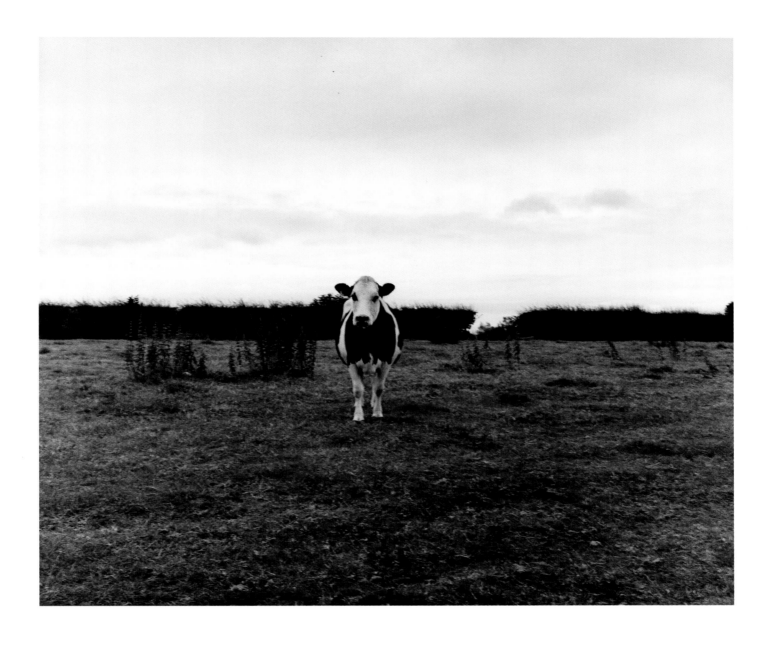

2001

Poor Cow 2001
C-type print 103 x 128 cm

Pyre 2002
C-type print 120 x 500 cm

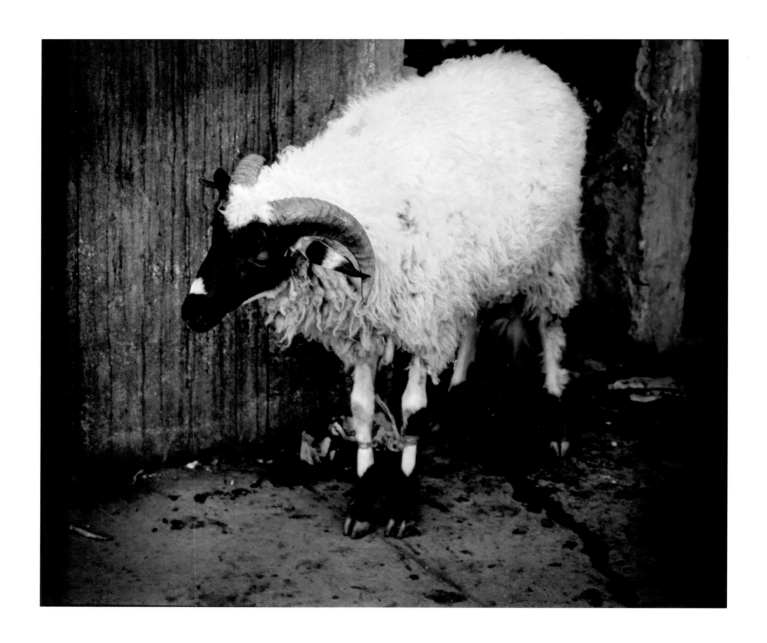

Bound Ram 2001
C-type print 50.8 x 61 cm

The Leap 2001
C-type print 246 x 180 cm

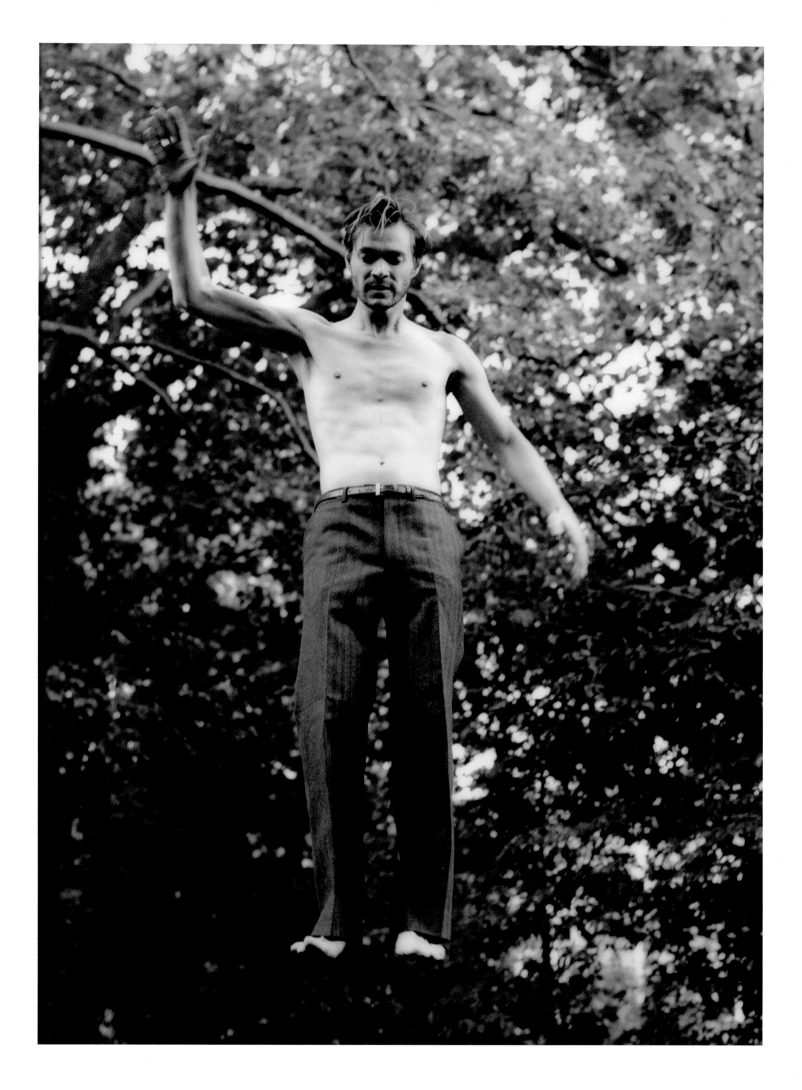

Soliloquy IX 2001
C-type print 226 x 257 cm

Breach 2001
35 mm 10 mins. 30 secs.

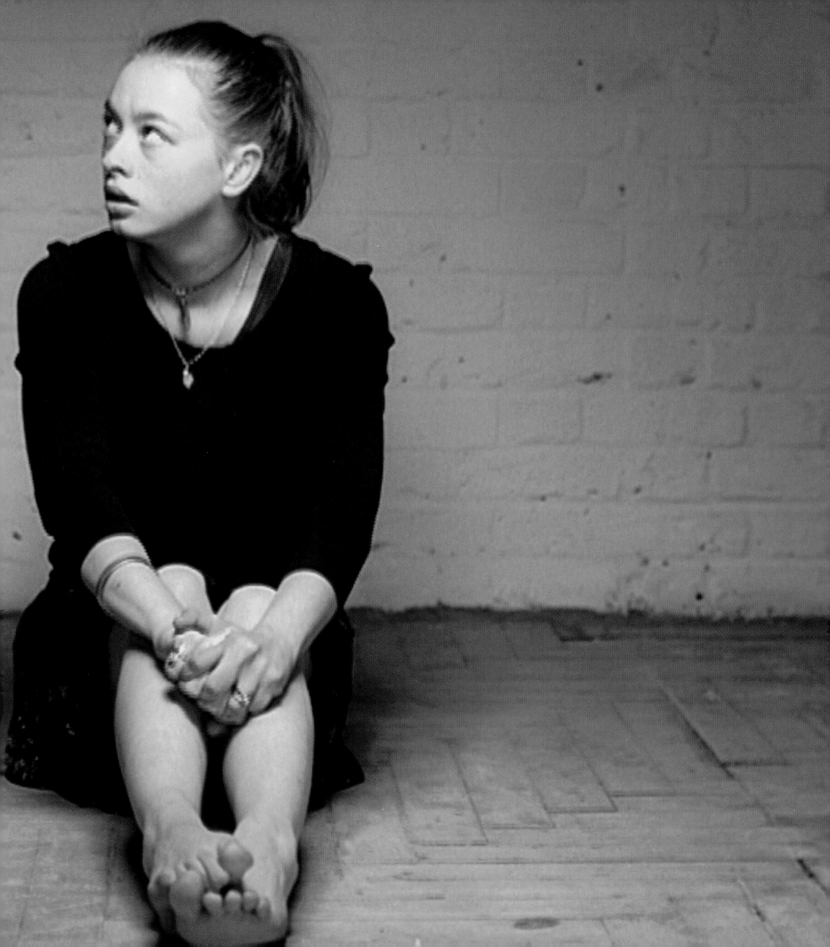

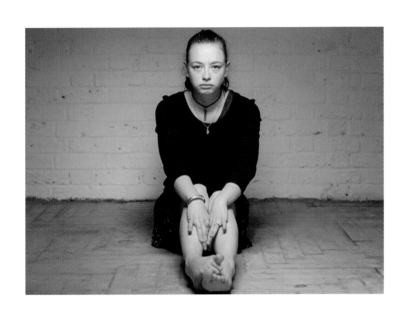
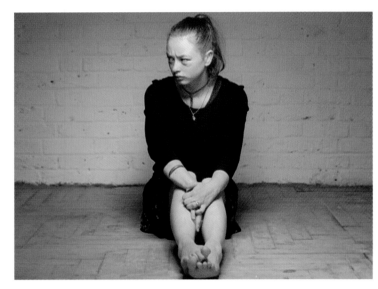
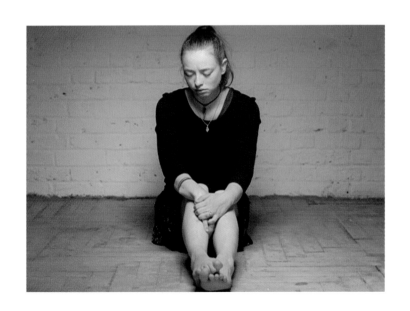
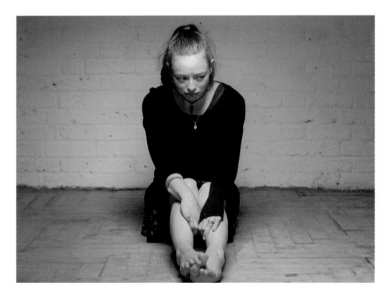

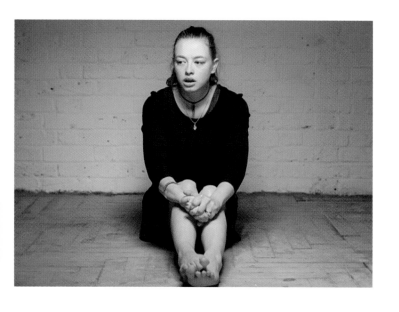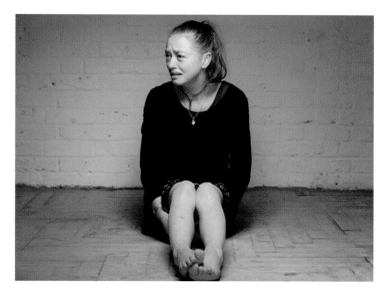
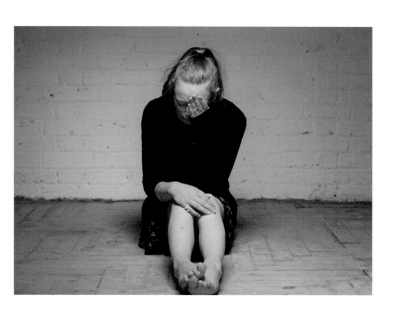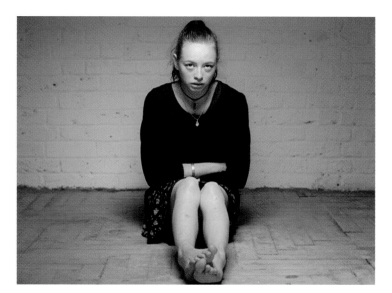

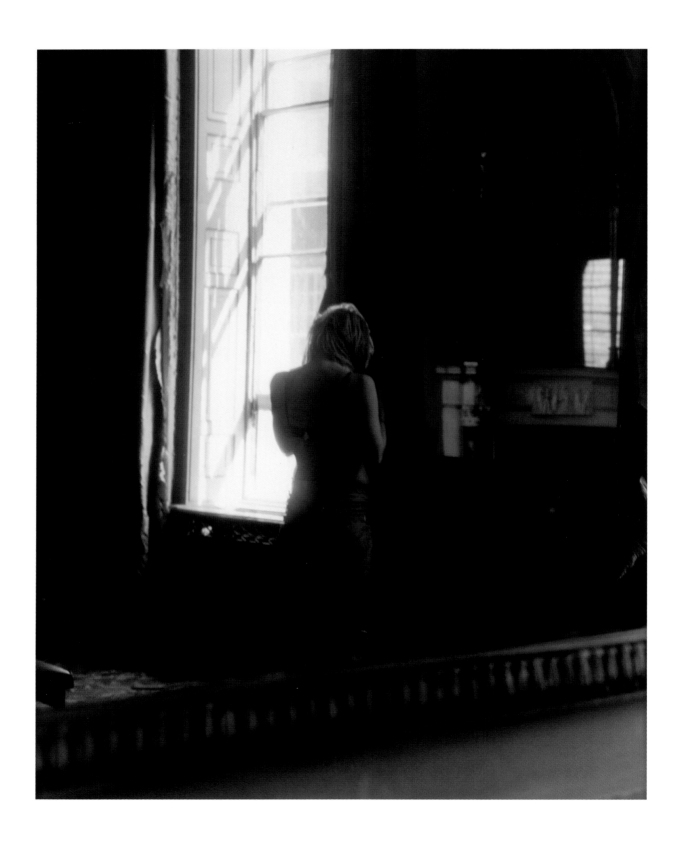

Self Love 2001
C-type print 126.5 x 102 cm

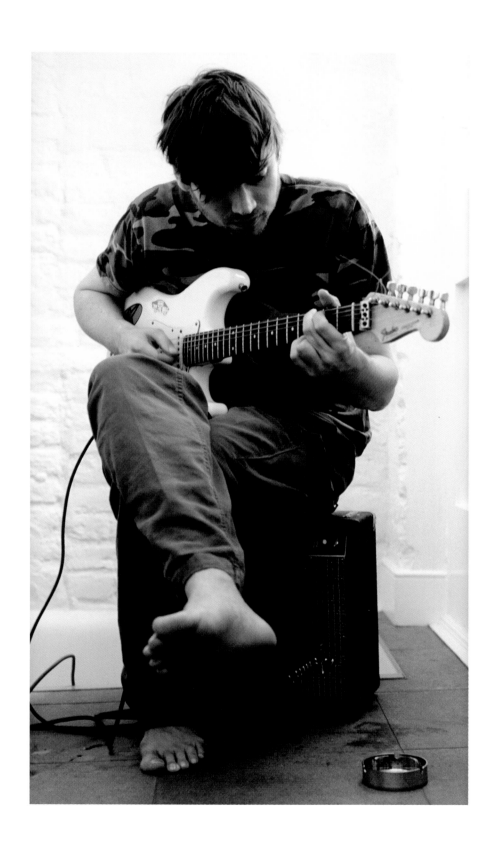

The Guitar Player 2001
C-type print 175 x 104.5 cm

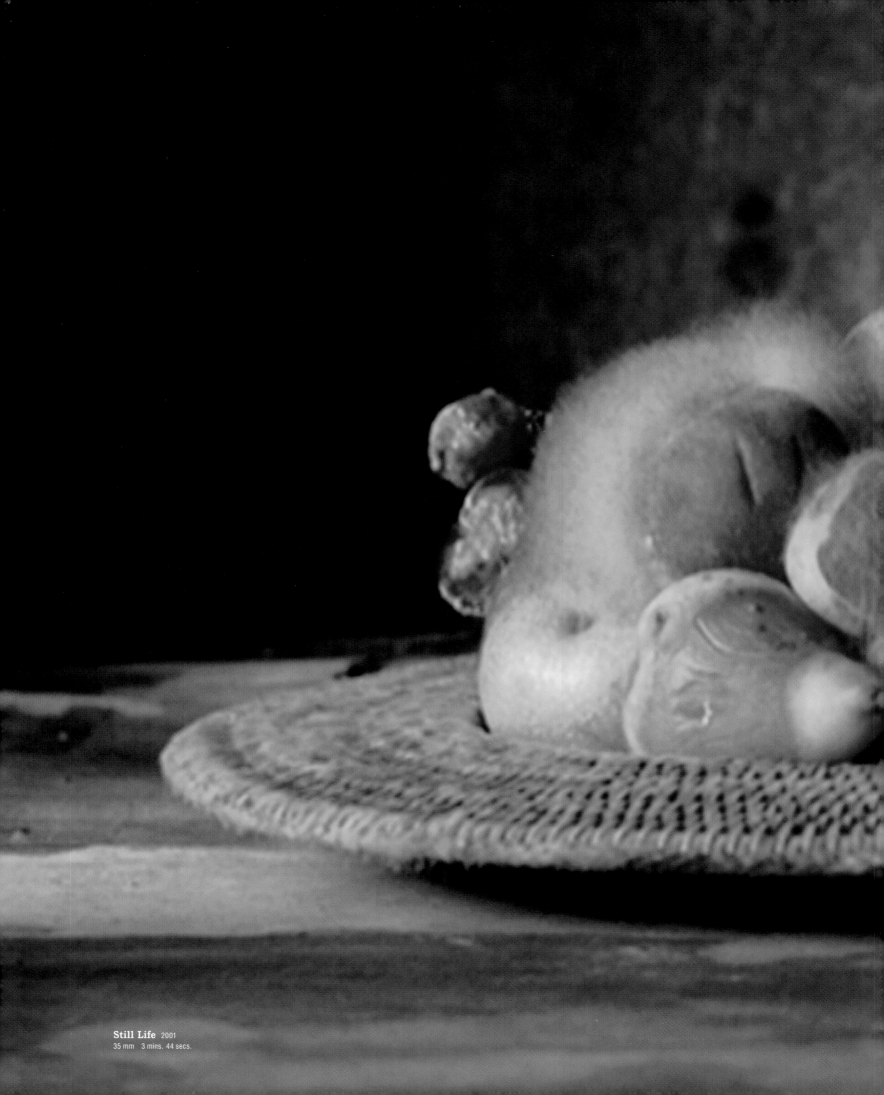

Still Life 2001
35 mm 3 mins. 44 secs.

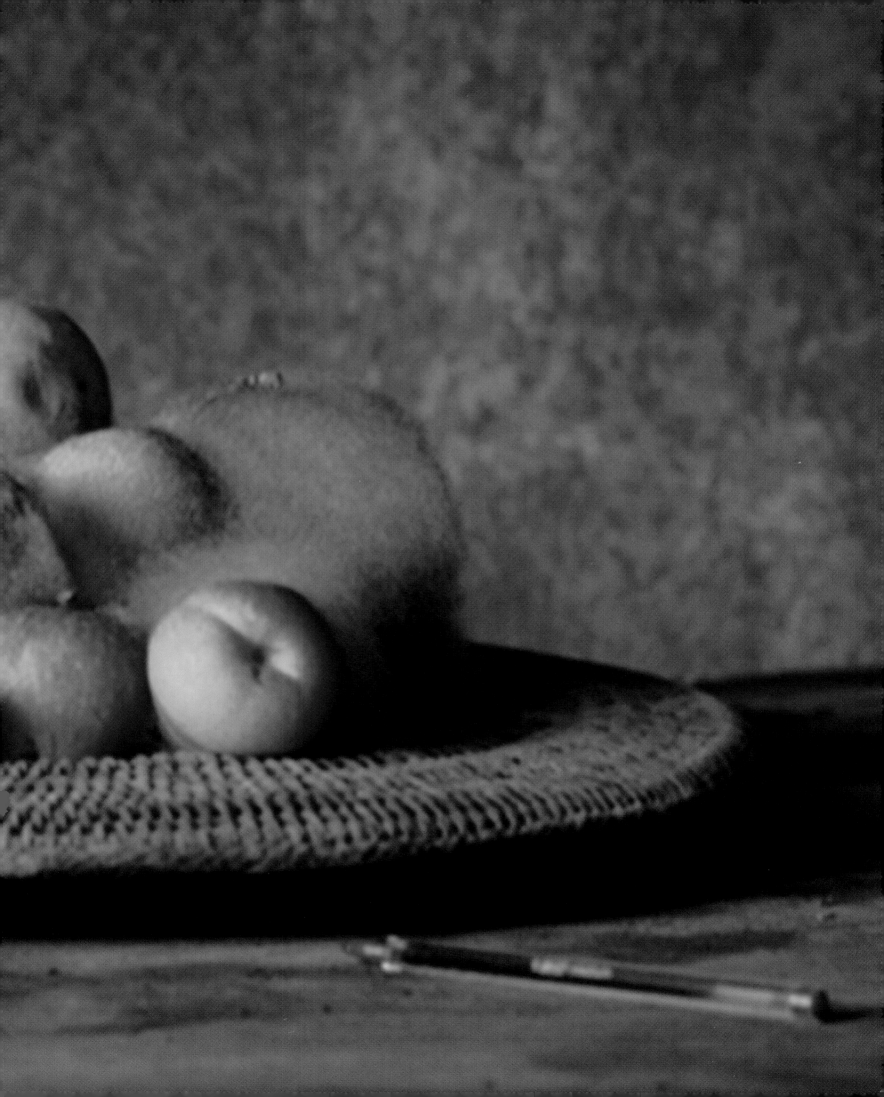

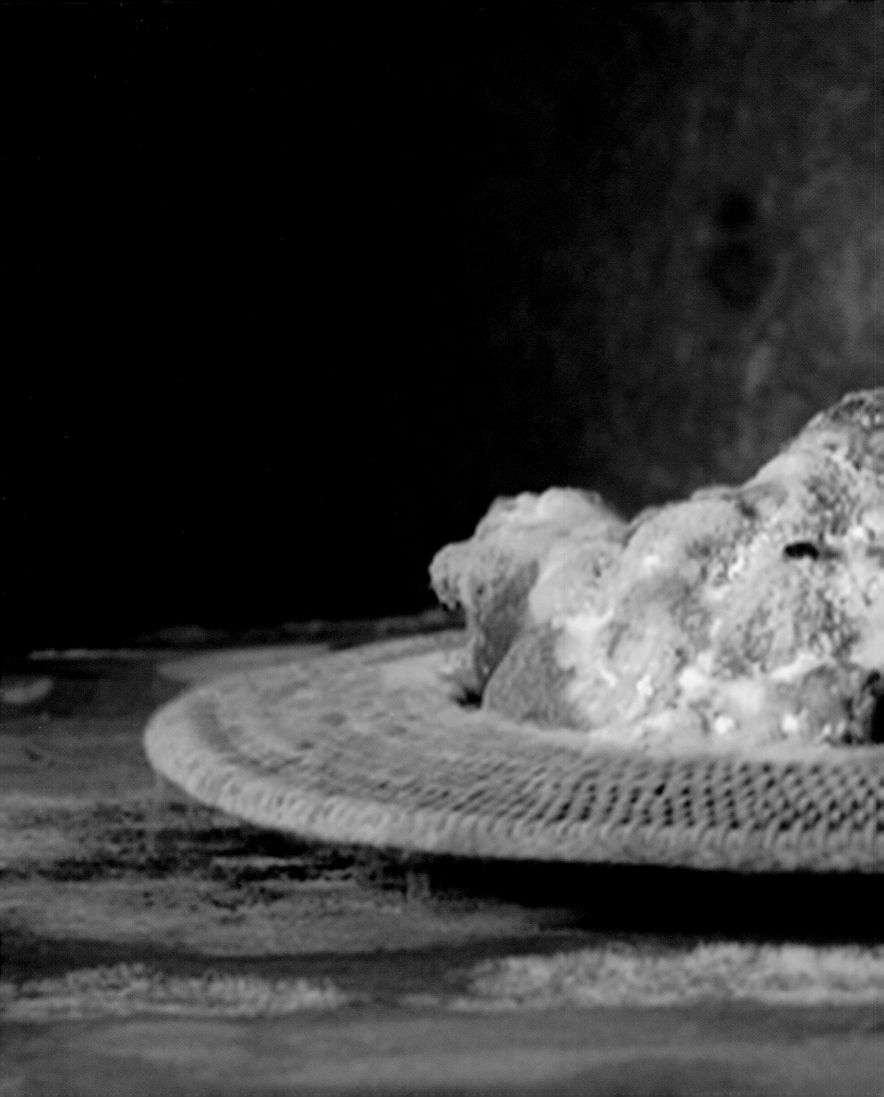

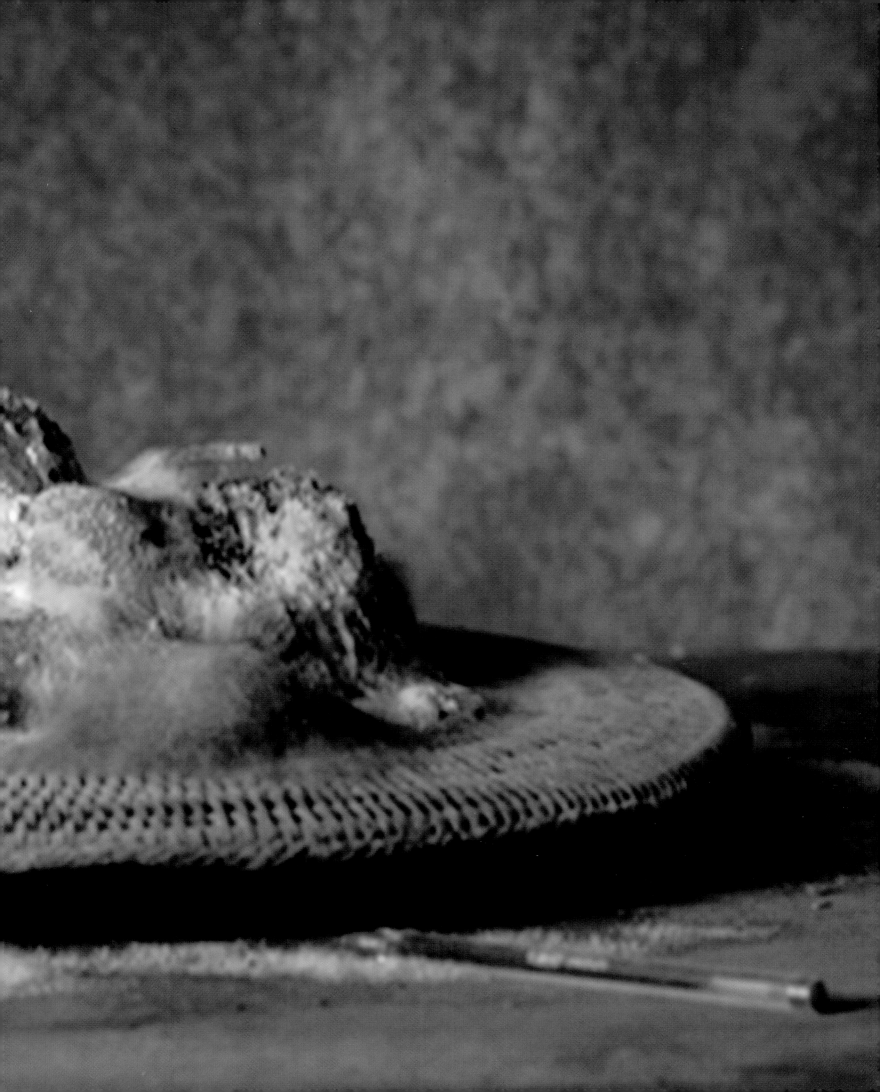

Elton John: I Want Love 2001
35 mm 4 mins. 38 secs.

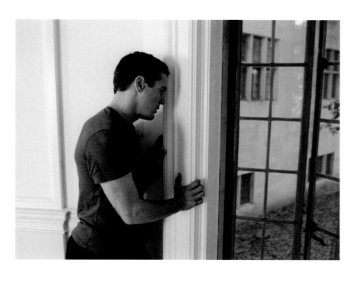

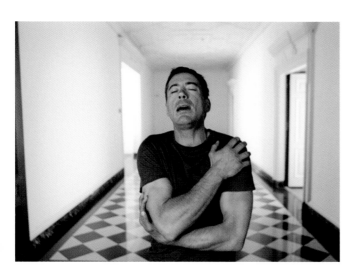

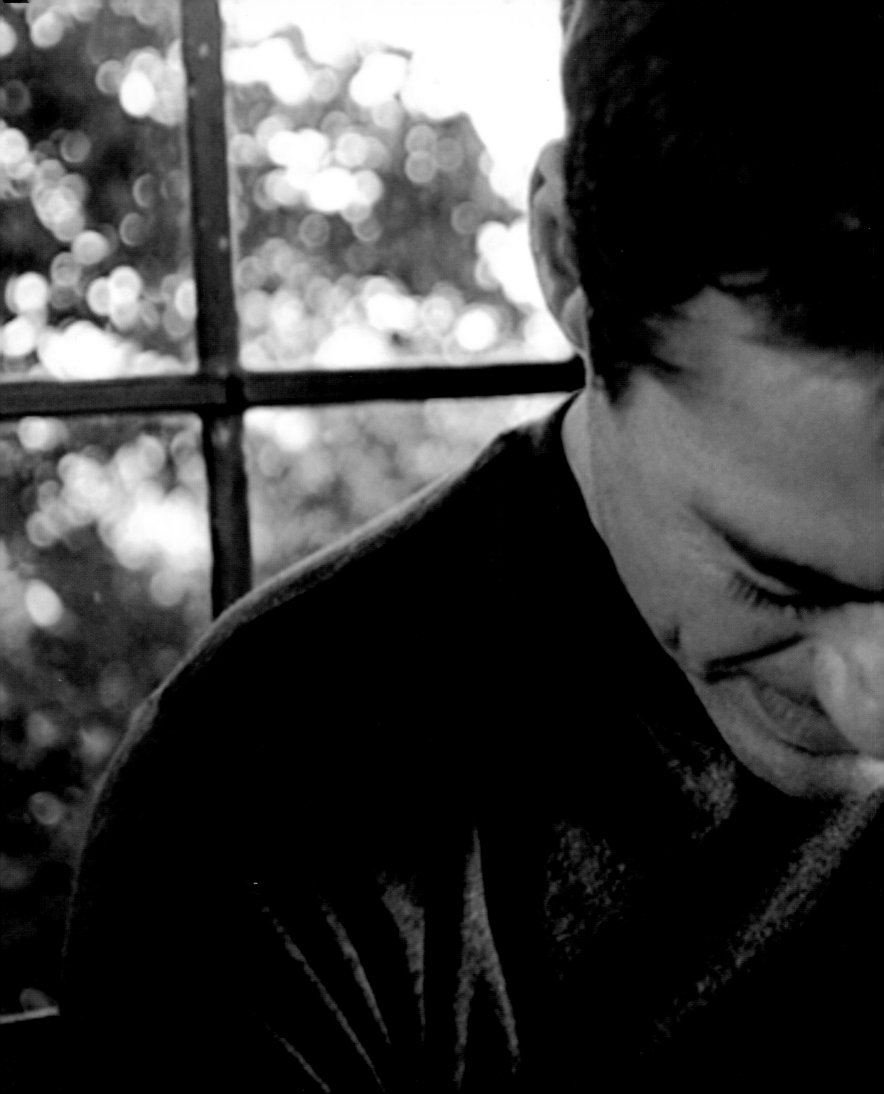

Mute 2001
35 mm 6 mins. 42 secs.

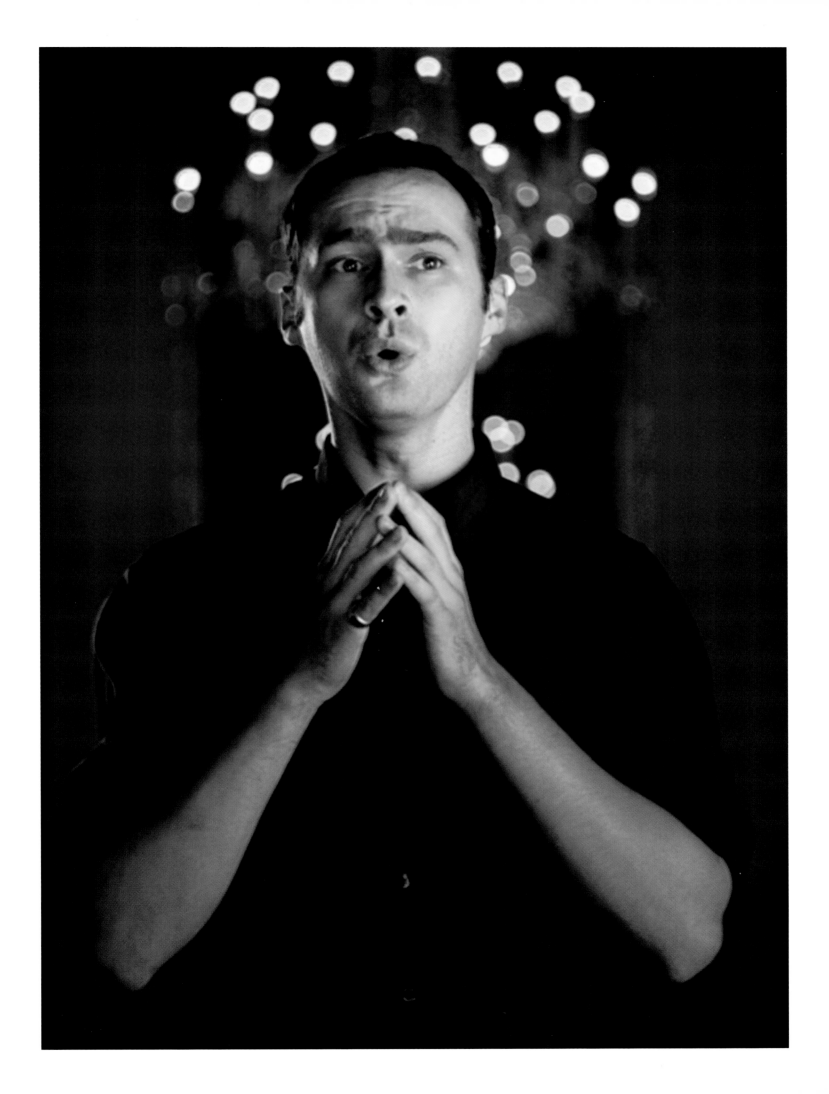

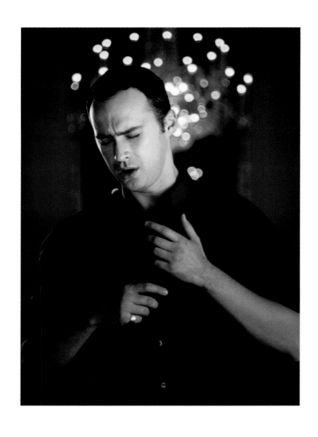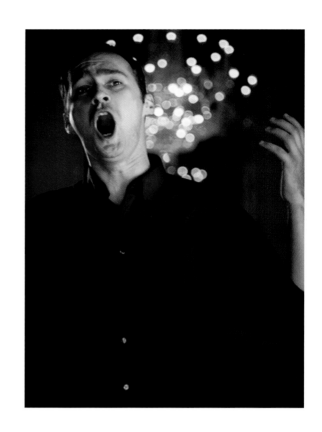
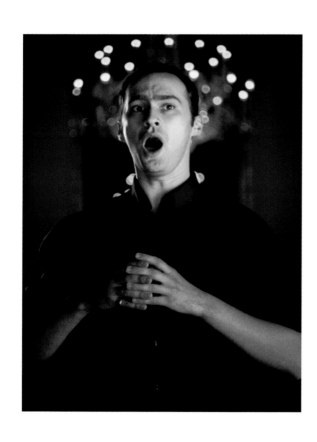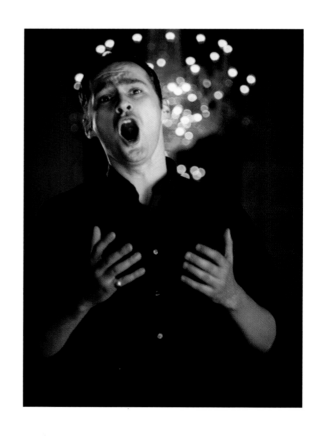

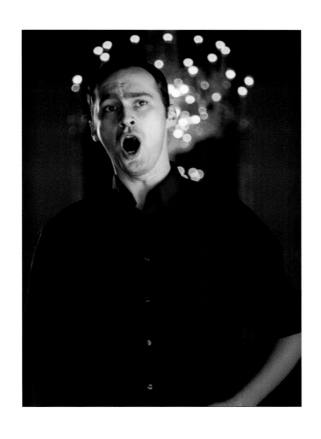
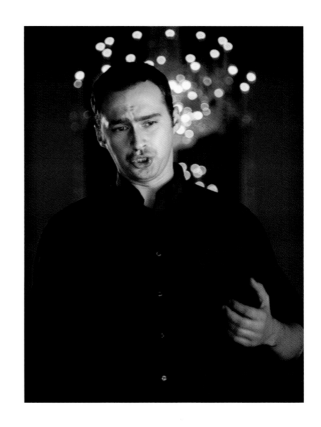
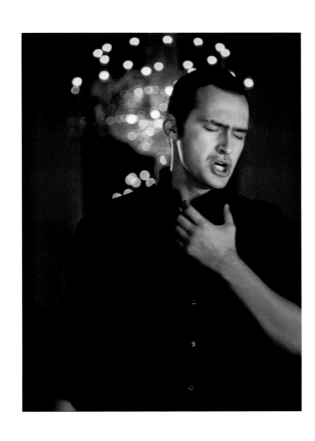
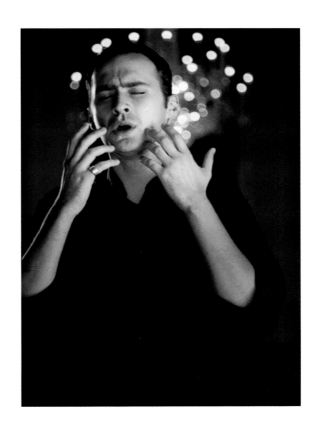

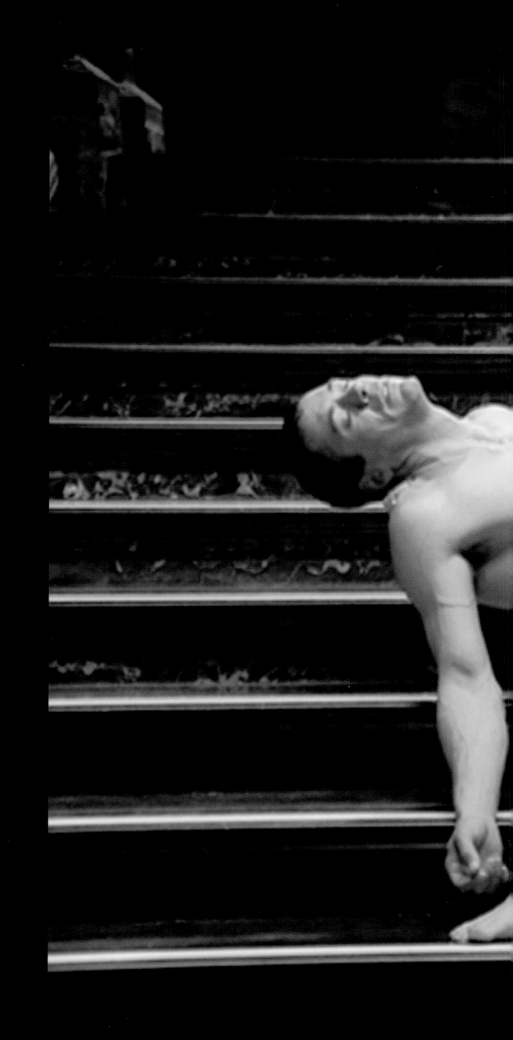

Pietà 2001
35 mm 1 min. 57 secs.

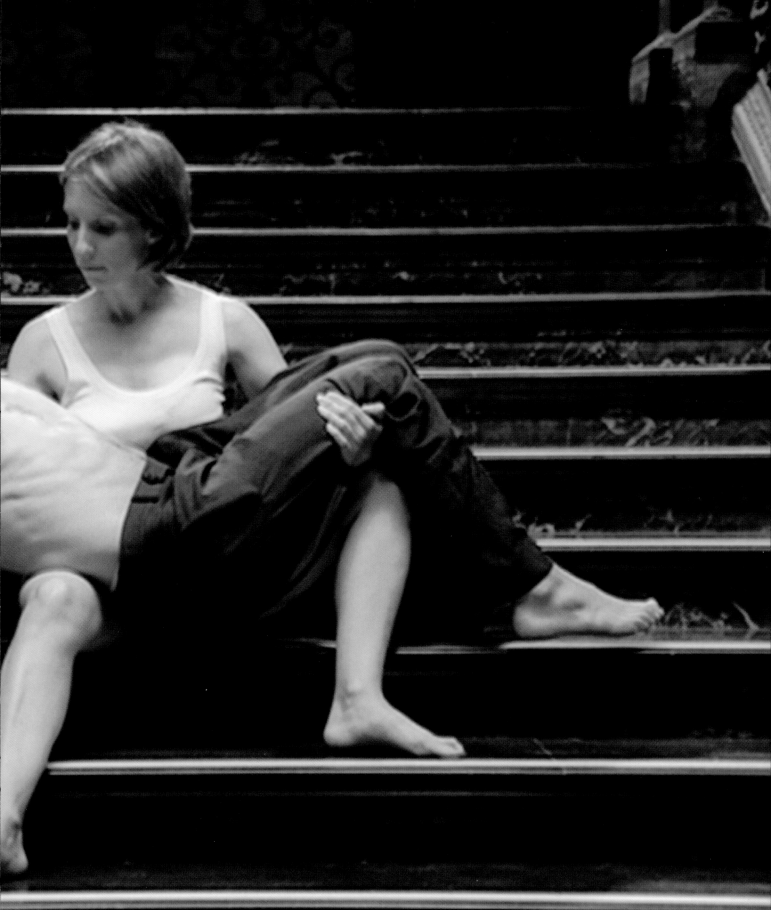

Interview with Sam Taylor-Wood

Clare Carolin: Early in your career you made a number of self-portrait photographs. Recently you returned to making yourself the subject of your work. Why do you make self-portraits?

Sam Taylor-Wood: They're punctuation marks within my work. I made the first portraits shortly after I had come out of college and was working at the Royal Opera House. I was making other work before, but it was part of a process of understanding what I wanted to do, not necessarily what I wanted to show. I was trying to find where I fitted in and also realizing that your work can be about who you are. Before, I was thinking in a much more convoluted and conceptual way. The idea of art was something that I held in such high esteem that I didn't see myself as an artist, I didn't see myself as worthy of that status. *Spankers Hill, Slut* and *Fuck, Suck, Spank, Wank* were about making a stand, discarding the old work and saying, 'This is me at the beginning of something'. Those were the first pieces that felt alive and immediate. Now, having made the more recent self-portraits, I'm aware of doing a similar thing; having gone through a certain period of my life and having to place myself within it, and also within the history of my own work.

In *Slut* and *Fuck, Suck, Spank, Wank* your eyes can't be seen. What did you want to say about yourself with those images?

Slut was the first self-portrait I made and I wanted to make a mask, to layer on make-up, black-out my eyes as much as possible, keeping a distance, saying, 'This is me but it's not me completely'. Closing my eyes took away any element of it being a confrontational image. It was a set-up. The love bites did not come from an act of passion – I actually had to ask somebody to do them. It was about the idea of someone being happy about being called a slut, having quite a glamorous image and at the same time there is physical evidence of sex. It's the same with *Fuck, Suck, Spank, Wank*; the language is confrontational but I'm in a vulnerable state with my trousers around my ankles. The sun-glasses shield me completely – so you can't get beyond the image.

When you made those two works in 1993 did you have an idea of where your life was taking you?

Definitely not. I was living for the moment. During those years I didn't make much work. I was trying to sort out how my life was functioning, juggling jobs and where I was living. It was quite a nice moment when I could actually conceive of an idea, let alone make something. Now things have to be much more planned. I'm asked to do shows years in advance. At different times in your life you work in different time-frames.

Does that affect the way you treat time in your work?

You tend to look at photographs instantly and read them quickly. With the *Five Revolutionary Seconds* series, I set out to make photographs in which you created your own structure and narrative whilst working within a different time-frame because you can't physically take in the whole image at a glance. You have to travel along the length of it and concoct a narrative. Alongside this there is a soundtrack, which lends the work a completely different time-frame because it's a recording made during the shooting of the photograph. So, the different time-based aspects of the work are playing against one another. Whatever narrative you construct from the photograph, the soundtrack is deconstructing. You might be glamorizing the situation in the photograph but the sound demystifies it by showing you how mundane it is, telling you what people were talking about at the time of the shoot; having their legs waxed, things like that. I also think about those photographs as showing different states of being simultaneously – you have one person who's bored, a person sleeping, someone taking drugs, two people having sex – you have the embodiment of all these different states of being within one room. It's like encapsulating one person in one room but within eight different bodies, each one not communicating with the others. It was also about all those different ways of removing and isolating yourself from other people. And all this takes place in five seconds; it's a momentary thing, isolated in time. When you look at it you don't know what happened before or after it, you only have this moment and from that you can invent whatever you want.

That seems to be a very consistent concern of yours. The idea that viewers construct their own scenario from the material.

It's about engaging the viewer without being didactic. When you see a film in a cinema you are manipulated and seduced and led through a story. A lot of my film works are more about making up your own mind about the situation you're looking at, how you place yourself within that and who you identify with.

Do you invent stories for yourself when you are making the works?

No, I normally begin with an image and work backwards. With *Breach*, I didn't have a story to explain why the subject was crying and so distressed. My initial idea was to make a film of someone fielding a barrage of insults and aggression. *Breach* looks at how you function and protect yourself in that situation. When I turned up for filming and was asked why the subject was being shouted at, I had to think quickly to find a reason. I never create a story beforehand. If I do make one at the time of filming, it's to help the actors understand what they are doing.

Do you want the viewer to empathize with the girl in *Breach*?

Yes, but at the same time I want you to be aware that it isn't real, that it's a film. You're looking at a range of emotions and a person struggling to be strong in a situation where they are helpless. You see that in the nuances and details, in the way that her eyes move. You also sense this third, unseen, unheard person. You feel their presence and you almost assume their position as the predator, the person who is inflicting this angst and making the subject vulnerable. During the filming there wasn't any shouting, the man – the third person – was totally silent, just breathing and moving around the room but you sense that he is shouting the whole time.

Was it difficult to get the girl, Lara Belmont, to do what you wanted?

Yes, it was horrible. But she's an incredible actress. I spoke to her regularly before we made the film and I kept saying, 'You've got to believe it totally for it to work; I don't want to have any element of disbelief. You've got to completely break down and build yourself back up again'. She said, 'No problem, I know I can do it'. During shooting I sat there with my stomach churning as I watched this person becoming increasingly distressed. Although you keep thinking it's just somebody acting, you feel responsible for the fact that you have asked them to do this.

Do you brief your actors based on your observations of other people's lives, films you've seen or personal experience?

Generally, a mixture of all three. That was the case in *Breach* and also in *Method in Madness*, which was influenced to some extent by Abel Ferrara's film *Bad Lieutenant*. With *Method in Madness*, I was trying to make something that was very tough to view, something that

Fuck, Suck, Spank, Wank 1993
C-type print 145 x 106 cm

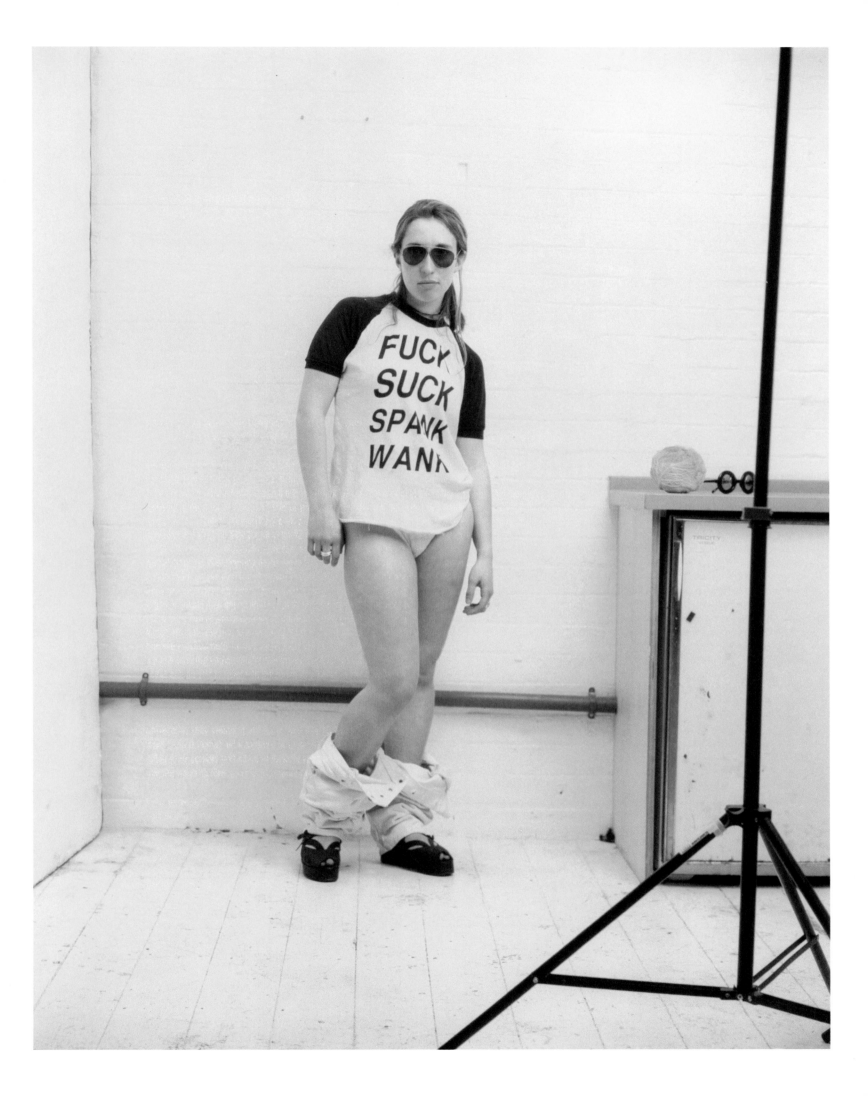

puts you in an uncomfortable situation. But then I set that piece against muzak as a way of reminding the viewer that it is a film, distancing them so they don't become too drawn in by the character and his dilemma.

In your earliest works you use friends as subjects, but the man in *Method in Madness* is a professional actor, as are the actors in *Sustaining the Crisis*. The actress who appears there, Amanda Ooms, is someone you've used in a number of works including *Travesty of a Mockery* and *Pent Up*. What do professionals bring to the work that amateurs don't?

You need to explain less and can cut through to the idea more quickly. Amanda Ooms is a great person to work with, not just because she's a really good actress but because we are very much on the same wavelength; she is interested in what I am doing and always understands the exact sort of performance I want. The man opposite her in *Sustaining the Crisis* was also an actor. The brief I gave to him was to describe what it would be like to look at the finished work, so that he could fill his mind with the imagery. He would be confronting a fear of this woman who was strong and powerful in her sexuality, but at the same time, was walking along very busy London streets without her top on. He had to think about the possible reasons why she is doing that. Is it because she is making a statement? Is it because she is on drugs? Or is it because she just forgot? I wanted him to act as though he feared something that he was constantly being pushed towards. *Travesty of a Mockery* was quite different. I wanted the couple to have a huge fight and I wanted the man, Michael, who isn't an actor, to rely on his instincts and to be himself and for Amanda to react by 'acting' a response. It put her slightly more in the driving seat: she was guiding the whole thing. In the piece she could be seen as a victim; in reality, she was the manipulator, because she was relying on her professional skills.

More recently you've started to cast celebrities in your work. Why?

It's a short cut to an idea. As soon as you see Ray Winstone in *Third Party* you know you're talking about a particular genre of film and also a particular person: a gruff, macho, masculine character. All the different characters that you know him to have portrayed are there in front of you. He doesn't say or do very much but you can project all these other roles and ideas onto him. There is a girl next to him, cropped just below the shoulder, so you never see

who she is. You can't put a personality or a face to her; she's a blank person. Then there's the Marianne Faithfull character, who again you can identify immediately as a famous partygoer – someone who's lived a life. She gives the work an immediate feeling and context, which would be difficult to express in another way. It would be hard to find a character who looks like they went to all those great parties in the '60s, who was a bit of a hippie, took loads of drugs and is now at a party in the '90s. But, using someone like Marianne Faithfull, it's already there. I try to use people who are known for very particular reasons.

You've also worked with well-known people in a different capacity. With Elton John and the Pet Shop Boys you were working to their brief rather than casting them in your own work.

Along with the Selfridges' commission, *15 Seconds*, I think of the works done for Elton John and the Pet Shop Boys as commercial projects and treat them separately to my art. I would never exhibit them in a gallery context because they are for a different audience and are made to help with the marketing of a product. The show that I did with the Pet Shop Boys was to promote them and their music; the Elton John music video was to promote his record, *I Want Love*. The Selfridges' piece was to work alongside the shop and for that especially I felt I had to use people who were well-known in order to capture public imagination on a massive scale. The same could be said about using Robert Downey Jr in the Elton John video. When you're making an artwork you don't have any of those preconditions or restrictions, you don't have to think about the fact that it is going to be on MTV and everyone has got to respond to it by wanting to buy a record. Having said that, I do think that the *I Want Love* video is one of my best pieces because it works well on so many different levels. I don't differentiate in that way, in terms of the quality. The distinctions are so blurred, I don't really know if there are any strong differences in the work itself apart from the fact that mass-production means a massively different audience.

An audience that recognizes and responds to celebrities?

I only use celebrities on odd occasions. But because I use them at all, people tend to assume I've done much more work with celebrities than I actually have. From a total teenage fantasy point of view it's fantastic to work with celebrities. But it's also interesting to work with your current cultural icons. It's another way of contextualizing your time. Everyone from the Renaissance artists to

Gainsborough has used important people of their current social situation as subjects. I think people are slightly more cynical about it now.

Why? Because they think you do it to court attention?

I think so; I don't really know. Though I seem to get asked about it all the time. But it's no different to making a feature film. I'm using the same criteria for much of it and dealing with the same stuff: electricians, gaffers... . The process of making my film works is the same as the process of making a feature film. Apart from the fact that my films are only three to ten minutes long. After I made the Elton video, I thought, now I've conquered three minutes I'm sure I could do an hour and a half.

Why do you think of the Elton John video as one of your best pieces of work? Why do you love it so much?

It's not just the final result but the serendipity of the process of making it. Everything just fell into place so beautifully. It felt like a fateful journey where everything is going according to plan. I agreed to do it on a Tuesday, Robert said he'd do it on Thursday. I flew out on Friday, we filmed it on Monday and it was on MTV the following Monday. The process was without fault. On the day of the filming you just know when something is going brilliantly, it has some kind of magic to it. I love seeing it because it makes me think how great things can be. I love to work like that. I spend so much time on my own planning, negotiating with people and finding locations to make the work, it can be such a long, drawn-out process. But the actual execution of my work takes only an afternoon or a day and that's the point where everything comes together and it's like magic. I was in control of a team of fifty people working on the Elton John video. It's hard to believe that when you see it, as it's such a lonely, quiet film.

Given that you had spent the previous year recovering from a second bout of treatment for cancer it must have been especially difficult to make that change from being alone with your thoughts to working with so many people.

Yes, really difficult. I had become so frightened of what my work would be. I didn't know how I was going to deal with the experiences I'd been through or where to begin. I didn't want to consciously sit down and think, 'Right, how do I portray this?'. I've always worked quite instinctively, so the idea of going through those experiences was just anathema. Doing the Elton video was great because

it kick-started a new phase in my work. It freed me up and gave me back the confidence that I had lost through not having made work for a long time. It sparked ideas, one after the other, with *Pietà* being the most immediate one.

Were you perhaps projecting your fear onto another person in that work? At the time you made the video, Robert Downey Jr was in rehab being treated for addiction to drugs and alcohol. It's a history of trouble quite different from your own but terrifying in the sense that it's also about being close to death.

I would say that it was a collaboration in that sense. At the end of filming the Elton John video, Robert was exhausted and we both just flopped down on the stairs. We had finished earlier than we had expected; we still had a huge film crew and all this film stock left over and Robert said, 'What shall we do now?'. He suggested that we do a mad version of the video where he is singing disco-diva style. But I'd recently been to St Peter's in Rome and seen Michelangelo's *Pietà* and said: 'No, why don't we do a moving *pietà* – a five-minute one?'. It just seemed like the right thing to do. I felt like I wanted to scoop him up and prop him up after he'd done this endless, sixteen-take performance. It felt like a totally natural process.

When you are shooting the film and video works do you have in mind how they are going to be installed?

Yes, definitely. I always begin with a strong vision of how the work is going to look and function in the space and that very rarely changes. The only real exception to that would be *16 mm* where I just fell on the equipment – the 16 mm projector – the first time I showed it. It worked so well that I kept it like that because the rawness of the equipment seemed to fit so well with the idea of the work, which shows a girl dancing to machine-gun fire. You sense that the projector is as likely to break down as she is, and the sound of it rattling away complements the sound of the machine-gun fire. It's as much a part of the piece as the film is. The equipment is not hidden out of sight as with many of the other works; it's part of the sound and the experience of the whole thing. But with the other multi-screen works the need for synchronization, or crossover between screens, means that the filming has to be precisely worked out beforehand. The placement of the cameras in *Atlantic* had to be so specific: there is a moment when the man crosses over and reaches out to touch the woman's face to stroke away a tear. If that wasn't perfectly synchronized, you would lose the magic of the

work. With *Killing Time* I had no idea, no technical clue how it would actually work. I just thought, I'll film four people; I'll start filming as the music starts and I'll join them all together. It sounded so easy, but we spent days trying to match the sound to the miming, to make it synchronize so tightly that it was believable.

How did the idea for *Killing Time* come about?

I wanted to take all the flat mundane stuff of day-to-day living and give it an injection of passion without changing its simplicity. I wanted it to feel as if these people were voicing their aspirations and dreams through the music. They appear to be bored but in their minds and hearts and souls there is this bubbling passion coming through the words of the opera; life collides like that sometimes and you feel two different emotions at the same time. It's also about the collision of high and low culture; my friends lolling about at home shot on cheap video matched with this operatic music, something that is so élite and fantastic, set so high up in our cultural stratosphere. I love the idea that the title, *Killing Time*, has two meanings: as well as the sense of the actors lolling about, the opera, *Elektra*, is about murdering your family.

You chose the soundtrack specifically for that reason?

I went through all the operas until I found one that had four strong characters. I didn't care too much about the story; that was an added bonus. The meaning of the opera wasn't as important as the structure of it and the passion and the violence of the music.

Did you shoot the characters simultaneously?

No, they were filmed over the course of several weeks. Andrea, the girl who sings Elektra, was filmed last as she had the biggest part to learn. None of these people are trained singers or actors; they had to be indoctrinated with German opera. Andrea was learning it while she was at the gym and going around the supermarket. It took her a month, studying every day.

So she was actually living the idea of the work while learning how to do it.

Totally; thinking, breathing, eating Strauss.

It's almost the opposite of *Mute* in which you have a professional opera singer actually singing, but with the

sound removed. Why did you take his voice away?

I felt it needed silence. I needed to extract a huge element. It was about fighting for a voice and not actually having one, which was how I was feeling at the time it was made. All my previous work had sound, so taking it away became a powerful statement. I wanted to create a deafening silence that the viewer could feel.

Do you feel more comfortable working with music and image rather than language and image?

It depends what I'm trying to achieve. For example, *Knackered* is very much about stripping away everything, making something that is totally exposed and then giving something to hide behind which is the sound-track. The music, which is a castrato voice, is also about someone having something taken away to give that voice. So it's all about reducing something down to its absolute basic. Reducing physically as well as within the image. *Travesty of a Mockery* uses sounds in quite a different way. It's the only piece I have made that's edited and it's done by changing the channels on a radio. Once again, as in *Killing Time*, it's about placing different sound to different emotions. It starts out with Classic FM and then you hear noise interference and then it changes to Kiss FM and then Radio 1 and so forth. It shows a man and a woman having a row and each phase of their argument has a different musical accompaniment. It goes through all these different sources of music and each one affects how you read the scene being played out in front of you. It changes your perception the whole time; you are constantly shifting to the sound.

How did you settle on the soundtrack for *Brontosaurus*?

It took months. I didn't quite know what I was doing when I was filming it, but I knew I wanted to make something that had this powerful element of life. Of course, the filming was hysterically funny; an hour and a half of me and the guy who's in it, giggling and rolling around laughing. Then I found a five-minute section and slowed it right down and looked at the movements he was making and tried to find a piece of music that highlighted the classicism of those movements, but at the same time the jarring, weird ludicrousness of what he was doing. I watched it with loads of different pieces of music; everything from The Rolling Stones to the Beastie Boys to Wagner. You instinctively know when something is right and it wasn't until I saw it with that piece of music [Samuel Barber's *Adagio for Strings*] that I knew what I was trying to do. Sometimes I

feel like the work is three steps ahead of me, working on a subconscious level. As soon as I saw the film together with that piece of music, it came slap-bang together and became something completely different to what it had started out as. It became a eulogy, a death dance, and at the same time a dance of life. That music is used in *Platoon* where it represents macho masculinity, going in and killing and patriotism. I put it in a completely different context and made it about something else.

So, in a sense, the music exposed the true meaning of the image. In film, the narrative leads the viewer to a point where image and music work together to express a moment of drama. What you seem to be doing in many of the works is isolating and condensing narrative and music. Is this what you aim to do?

It's conscious in the sense that when you go to the cinema you are aware of how music can manipulate emotion. An image of a woman walking down a road, for instance, is quite straightforward. It is what it is. But depending on the music that's put with it you feel different things; if the image is accompanied by the music from Hitchcock's film, *Psycho*, you feel fear; with another piece of music you might feel that she's going expectantly to meet someone. Music can change your emotions as much as words or images and you don't necessarily have to understand exactly what is happening in order to sense the emotion through the music. Music works in an amazing way because it taps into you so quickly and makes you feel an immediate response. Someone once said, 'Music is proof that God exists'. Whatever you believe in, it's that sense that music is on a completely different level. It hits you immediately.

Would you say then that music is more expressive than image?

No, just different. It's the collision of the two that makes something powerful. Music adds that other dimension, to really heighten, or change or highlight something.

You mentioned *Psycho*. Has Hitchcock been an influence, in the way that he combines image and music, or in any other sense?

Hitchcock was probably one of the first filmmakers who made me look at films seriously. The first film I saw of his was *The Birds*. It's such a brilliant film. The images are so stark and straightforward, and there's this slow build ...

one bird sitting on a tree, twenty birds, two hundred birds ... and then the music. It's so simply done.

What about Orson Welles? There's a long tracking shot through a mansion in *The Magnificent Ambersons* that reminds me very much of the Elton John video.

I haven't seen *The Magnificent Ambersons*, but at the beginning of Welles' film *Touch of Evil* there's a similar, incredibly long shot, a single take that feels as though it lasts for about ten minutes. Kubric is another director who used extended shots, but spinning through 360 degrees with the camera swooping around, especially in *Eyes Wide Shut*. The effect is that you immediately feel that the person who is seeing what the camera sees is singular to their environment because the camera gives a perspective of everything from a single point of view.

So it's similar to the spinning camera in *Third Party* and the panoramic shots in the *Five Revolutionary Seconds* and the *Soliloquies*. When you are watching films do you find yourself looking out for moments like that that can be incorporated into your work?

There's an incredible shot in Kassovitz's *La Haine* of people on a balcony. The people stay absolutely still and in focus while the background goes right out of focus and then suddenly moves back in. I wanted to do something similar in *Breach* so it would seem as if the girl was suddenly seeing something for the first time; having a revelation. But I never did it because I felt that it would all have been a bit too convoluted. I tend to pare everything down to its minimum, every type of clever film technique that I want to reproduce I tend to eradicate quite quickly. In *Third Party* the movements are minimal; the individual cameras are almost completely locked off and focused, apart from the one that spins around the whole room. Technically, that was really difficult, because we had to keep spinning it around the entire space and not take in any of the six cameras that were also filming. It was about giving a perspective of the whole party but not long enough for you to really take anything in; giving you a sense that there was a bigger party going on and other people there, but the piece was just focusing on a few people.

How involved do you get in the technical realization of your own work?

I function in the same way as a film director. I have the idea and the vision and I pull in the people to help make

that vision possible. I'm not interested in learning that technology myself, so I work with people who have the sort of knowledge that I don't. The thing is that because quite a lot of the works are technical it looks like I do have a technical brain. I'm interested in pushing technology, but with the help of others.

People often talk about the similarities between film and dreaming. You go into this dark space...

You become embryonic in a way, you hand over your power.

What's the first film you remember well?

I remember seeing *Whistle Down the Wind* with my mum when I was a kid. I love that film because of all the possible double meanings, the cross lines and cross purposes. Alan Bates is a murderer on the run and there's a group of kids who believe that he is Jesus. In the final scene the police chase him across a cornfield, they catch him at the top of a hill, and it's filmed from below. They frisk him, he has his arms out, he's flanked by a policeman on either side. That's an amazing image to remember and the film itself is also such a great construct, it reflects so much of our religious upbringing, our belief in a romantic story. The audience assumes the position of the kids who want to believe the story so much that they invent a reality focused on this person who is the image of what they want to believe in. It's a child's logic: because he looks like Jesus, he can't possibly be a murderer. It's about blind belief in an image, how your need to believe that something that is all good, all romantic and all beautiful can transcend rational sense. It's the desire to have what Freud called an 'oceanic feeling', the feeling that you just want to be carried away by a tide. What comes with that feeling is a desperation to believe in something, to have something to pin your hopes on.

Do you believe in God?

I don't believe in Christianity in any conventional sense. I do a lot of yoga and meditation so I believe in an essence of life, a spirituality. From my perspective it's about what you find within yourself, being your own guide and teacher. I grew up with that desire for a romantic belief in something. My religious upbringing was confused. I asked my mum one day, 'What are we?', because everyone at school was saying, 'I'm a Catholic, I'm a Christian', and my mum said, 'Oh, we're Hindu'. We had an altar at home that had a crucifix on it, an image from the cover of Kahil

Gibran's *The Prophet*, a framed image of the prayer hands, a Buddha, a poster of Krishna, and a Virgin Mary. It covered almost every aspect of every religion. It was about as confusing as you can get. I grew up so desperate for something that I took up with the Church for a while. No one in my family was that way inclined, churchgoing, so I decided to do it for myself. I went along for a while and then I lost belief in the Church.

Why?

There was a guy who was there, he was black, which was rare in the Church, and he was deaf. It meant that when everyone started to sing, he'd sing too, but he didn't have any sense of pitch, tone or sound, so he would sing really loudly and totally out of tune. The older congregation signed a petition to have him banned from the Church. I remember him being absolutely distraught, beside himself because he wasn't able to belong to something. He was a friend of mine, and I just thought, if that's Christianity then I don't want it. I never went back after that.

When did you first use a religious image in your work?

Wrecked was the first time I used an image overtly. But prior to that a lot of my work was indebted to religious imagery in the sense that it focused on, dramatized and gave importance to a single person in much the same way that images of gods and saints do. With *Method in Madness* I didn't set out to make a piece of work about Christianity but it's religious in the sense that it shows someone suffering and it is also about the ten-minute process of watching that.

How did *Wrecked* come about?

It was made at a time when it felt as though there was a real hiatus in the art world, everyone was out all the time, drunk or on drugs. It came out of my sense that everyone was going completely wild – it's a mad dinner party scene. Structurally it's based around *The Last Supper* but the point of it is similar to the *Five Revolutionary Seconds*. There's a room full of people, everyone's a bit crazy and drunk and having a mad time, but there's a central figure who is liberated and free of it and has chosen to separate herself from the rest. Making her topless wasn't about trying to be controversial, sacrilegious or shocking; it was more about basing the work around something we formally understand, taking the central figure and using her to refer

to a moment of freedom. So what if she wants to take her top off? She's a bit drunk at a party, she doesn't care about anyone else, and no one cares about her either, she feels elated and separate.

Inevitably that work is often read as some sort of feminist statement. Do you think of your work as being gendered?

Not consciously. Gender is an issue to a certain degree, more so in the earlier works, which were about defining myself as an artist, and as a woman artist. The groundwork is there, but I don't sit down and say, 'This is about a certain aspect of my femininity or a certain angst against my femininity'. It carries through the later work but it's more subtly placed.

Up until very recently the subject matter of your work has been almost exclusively urban – the characters are urban types and the environments are clearly metropolitan. Recently you have begun to introduce pastoral subject matter. Why the long resistance to nature and then the change?

I used to hate the countryside. I grew up in Streatham but when my mum got divorced and remarried she wanted to start a new life and we moved to the countryside, to Sussex. For me, it was just the most horrible thing in the world to go from being this budding teenager down at Streatham cinema and the ice rink to suddenly going to live in this horrible, strange town called Crowborough – the borough of crows. That says it all. It was so dark, everything about it made me feel uneasy. I hated it. I had this fear of walking down country lanes where everything was growing over you. Bringing the pastoral material into the work came from having a whole year to be contemplative. When you go through chemotherapy the last place you want to be is in a city. You don't want to talk to people; the sound of the phone hurts your head. You want to be as serene and quiet as possible. I spent a lot of time in Yorkshire just staring at nature. You become a cliché, looking at sunsets and saying hello to robins. You start noticing all the things in life that normally speed by.

When you made *Self Portrait as a Tree* were you thinking about the history of landscape painting?

Not at all. I was lying on the sofa and someone said, 'Come and look at the tree, it's so amazing at the moment'. And

I went out and took my camera with me and took a picture and thought, 'Oh, that's so beautiful'. Months later when I was going through everything again – because you tend to forget time when you're going through chemo – I came across those contact sheets and thought that that single image summed up everything that I was feeling. I did not have to explain it through a narrative piece of work. It was only later that I realized that it's great because the history of landscape painting is there, that it looks somehow like a work by Caspar David Friedrich. When you are making a photograph you have a memory bank of images that work their way in subconsciously. *Bound Ram* though is a more self-conscious reference to Zurbaràn's *The Bound Lamb* ('*Agnus Dei*'), which I saw in the *Seeing Salvation* exhibition at the National Gallery a couple of years ago [2000]. It was the only work in the show that was not a figurative representation of Christ but was still about innocent sacrifice and suffering for other people. The photo is printed the same size as the Zurbaràn painting. It was taken in a market in Marrakesh about a month after I had finished chemo.

Moments of angst in isolation appear in your work from very early on, free from narrative and apparently free from allusions to personal experience. Why take those moments and headline them?

Many of my works are about being placed in difficult positions, which normally aren't public. They are hard to watch precisely because they are not part of a narrative. I'm interested in looking at how humans respond and react in moments of crisis. I want to examine the physical manifestations of anxiety. It's not just an obsession on my part about people having crises.

It's just that there are a lot of very highly distressed, lonely and anxious people in your work. There's not much happiness.

I've tried. *Brontosaurus* was my attempt at happiness. It was a joyous piece of work, but it all went wrong. It's just not in my repertoire. Distress is a recurrent theme that I feel I have to investigate and in the more recent work it has a very clear context. *Breach* came from that feeling of living with fear, of life as an unending attack. You never know where something is going to strike from next or what's going to happen to you. You have no idea where you might find redemption but you live in the hope that you will.

The Art of Sam Taylor-Wood

The great Italian director, Luchino Visconti, was interviewed about his film of Thomas Mann's novella *Death In Venice*. Archive footage shows the casting screen tests, filmed some time around 1970, for the boy to play the beautiful youth Tadzio; in an ornate, sombre, high-ceilinged room, all gilt edges and faded crimson plush, probably at the Hotel des Bains on the Venice lido, a succession of liquid-eyed teenage boys glide across the floor, some glancing with a shy smile into the mercilessly static eye of the camera. 'To put your eyes on beauty', said Visconti, 'as you know, is to put your eyes on Death.'

A portentous pronouncement, but one that seems to describe, in my opinion, the thematic span of Sam Taylor-Wood's artistic practice. On the one hand, her films and photographs present a sheer sensuality of surface which enfolds the viewer in a kind of empathetic luminescence – a human warmth, conveyed through light and texture; on the other, as the works maintain their narrative course, frequently enigmatic, often shot through with a delicate tracery of post-modern allegory, the viewer can be left with a sepulchral chill: what is the soul journey of these handsome, frail, self-immobilizing figures, caught in some sort of dream world between fantasy and trauma? It feels to me as if they take their place, poised between the vacuum of a Godless materialism, and the half-formed, barely comprehended, existential shock of their own mortality. But always, in Taylor-Wood's art, there exists the predicament of how we articulate that shock.

We might consider this broader position in relation to Taylor-Wood's two-screen laser disc projection from 1997, *Sustaining the Crisis*. A young woman – made up as though for the working day, perhaps a chic young executive – is walking down a featureless urban street, but naked from the waist up. Opposing her (or so it seems), from the second projection, a handsome young man whose emotions are passing from distress through hostility to disbelief.

There could be almost any kind of conflict going on (sexual vengeance? ritual humiliation?) but there is also an overriding sense of unease. It is rather as though we are seeing into the sub-conscious of a situation: an emotional state described visually, and one which seems to articulate trauma – our sudden awareness, perhaps, that we are trapped within our own lives. Destiny, rather than a road ahead, becomes a trial by claustrophobia. (Another shuffle of the deck and this handsome young man could be seeing a ghost, or a figure released from his dreams – some kind of presentiment, at any rate, to disturb the equilibrium of his emotional weather. This is a short story – 'a deed that hath no name' to borrow from Shakespeare – which balances the weight of its proposition on that sense of time's slippage which occurs during fear.)

Taylor-Wood's art, I feel, takes its place at the point of contact between psychology and destiny – the twin poles, if you like, of the human condition: how we react to life's journey. And that transaction between Beauty and Death, observed by Visconti, is described through Taylor-Wood's art in terms that are allegorical – in the Augustan, eighteenth-century sense of relating to classical ideas of mortality and resolutely rooted in a post-modern experience of urban life.

To find a way of looking at Taylor-Wood's art in relation to its times, you could think of her work as scenes from the sub-conscious of modernity: a multi-layered response to what we might call the critical mass of post-modernity, as it takes its form within the emotional landscape of the individual. In this much, she examines a generational experience of having inherited an over-loaded culture, in which the sheer weight of influence and information created cultural gridlock from its very accretion of ideas, images and history: the 'so much of everything moment', as the trend-analyst Peter York would sum up the soft centre of cultural materialism in the 1990s.

Taylor-Wood, in this respect, is one of the few contemporary visual artists who is utterly at ease within Pop, for the very reason that her work has no engagement with up-dating Pop Art. Rather, there is a breadth in her vision that enables her to respond to Pop as a situation, rather than as a rhetorical event.

In her work for the Pet Shop Boys – a film-installation set for their *Somewhere* concerts at the Savoy Theatre, London – Taylor-Wood seemed to describe, once again, the subconscious of a situation: in this case making a group of increasingly drunken and partying people appear like a visual sound-track to the live music being performed by the Pet Shop Boys. As Chris Lowe and Neil Tennant walked out of the 'real' time of their concert, they reappeared (and technically, this required split-second timing) on Taylor-Wood's screen within the parallel reality of the filmed party. Thus, rather than reacting to the event of live pop music, Taylor-Wood's setting realized the 'idea' of a concert by the Pet Shop Boys – the state which their music might seem to convey. In this, Taylor-Wood's art pre-supposes that we live in a society where pop is a given condition, no longer sealed within a cultural niche, but as ubiquitous as technology itself.

Transposed from the broader experience of urban life to the psychology of the individual, however, this issue of critical

mass could also mean: so much thought, so much fantasy, so much need to communicate, that expression short-circuits through a crisis of identity. And so from this must emerge a broader conundrum: 'how do you deal with so much stuff?' – Rearrange it? Parody it? Destroy its currency?

These founding themes weave their presence through Taylor-Wood's three-screen projection, *Atlantic*, 1996, in which a glamorous situation, seductively filmed, attempts to resolve its own neurasthenia, locked between trauma and opulence. More or less contemporary to *Atlantic* is the publication of Brett Easton Ellis' novel, *Glamorama*, 1998, which one feels could be a literary investigation of a similar sensibility: the grid-lock of wealthy Manhattan, in which characters over-load as transmitters of too much of everything. *Glamorama* was advertised with the slogan (exclaimed, I felt, with a weird kind of self-defining heroism): 'We slide down the surface of things'. Is this the shared fate of Taylor-Wood's subjects? Or do they rather (to borrow from the nineteenth-century philosopher Kierkegaard), 'feel like the chess-man, of which you say, "That piece cannot be moved".'?

While the post-modern landscape of late capitalism (most notably from a bourgeois perspective) raises issues of mediation, perception and intentionality, (how do we see things, now that there's so much to see, and so many different ways to see it?) so Taylor-Wood's idiosyncratic engagement with destiny, or our place in the scheme decided by conditionality or fate, becomes articulated through her art as the system that we carry around encoded on our existence. If we're like the chess-men that cannot be moved, (held in checkmate by our destiny) then how did we live out the moves that led to our capture?

Combined, these two factors, one of how we see, and the other of how we act, could be said to clear the land or stretch the canvas for Taylor-Wood's perception of the human condition. Her four-screen video installation, *Killing Time*, made in 1994, seems to pretty much define her position as regards the individual's place in the universe. This is what you get: four screens, four people, and a passionate sound-track of German opera. But what kind of people are these, and what, exactly, are they doing?

The participants in *Killing Time* look like your average inner-suburban, low-to-middle income bracket, ever so slightly funky types, anything from librarians to cycle couriers. They mime the parts of the opera, but separately, on their different screens, and without the faintest attempt at expression, acting, or anything. They look bored, basically, and in this much they pun on the title of the work. But is the killing of time an active or a passive pursuit?

What seems to have happened is that *Killing Time* (an early (-ish) piece) describes Taylor-Wood's concerns around immovability, communication and fate, as they are transposed to the sphere of human relationships – an algebra of conditionality in which none of the equations will resolve, but the factors (people, their emotions, their longing to express themselves) keep cancelling one another out, like the old way of solving fractions by crossing out common denominators.

Rather than slackened with apathy, the 'characters' in Taylor-Wood's film pieces of the middle to late 1990s appear to become increasingly taut within their ambiguous situations, straining between the polarities of extreme states of mind, battling with constriction. Two major pieces exploring this position are *Travesty of a Mockery*, 1995 and *Pent-Up*, 1996. In the former, a domestic argument appears to turn violent; in the latter, isolated by their own feelings, but collective through their shared solitude, five individuals attempt to co-exist – with themselves. This is like the world of lifestyle television turned on its head, with emotional dysfunction taking the place of cheerful development.

But the people in these films appear to exist in an ambiguous state, and, I suspect, are meant to; they could be actors, friends, participants in some of kind of popular factual programming docu-soap (although they're too wired for the format) or they could be psychological archetypes – the Proustian notion of 'the many gentlemen of whom I am comprised'. My own guess is that, somewhere in the creative chemistry, they are all like chess-men of which you say, 'that piece cannot be moved'. They are figures on an allegorical frieze, in this much.

You can return to these film pieces again and again, hoping for some experience of them that will release the characters from their trial by claustrophobia. But it never happens. Instead, the films maintain the extraordinary lustre of their surface texture – lit to a degree of near hyper-reality, in either cold blues or warm amber – in a way that conveys intimacy and distance, simultaneously. Vitally, the subjects in the films seem to be almost 'too there', too vivid in their heightened emotional presence. And this, of course, is how we tend to witness the crisis points (which can sometimes be very subtle) in people's feelings – their encounters with destiny, played out through domestic circumstances or sudden isolation, that moment when the straw finally lands on the camel's back.

The effect is heightened in Taylor-Wood's film pieces by the contrast between the 'too there'-ness of her subjects and their accompanying sound-tracks. Her use of sound – evolving from opera to the Beastie Boys to radio channels to silence – has the effect of re-routing our sense of tuning in to a particular event. She uses sound as a kind of emotional blocking signal – a further restraint on the relief of catharsis. You see this best in *Hysteria*, perhaps, with the woman's silenced cries. This is a universe in which action (as Hamlet lays out) is forever suspended, caught in a spiritual (and that's an important word) void between the Either and Or of a given position.

In her film works and in her large-scale photographs, Taylor-Wood seems to be making philosophical studies – not in the conscious academic sense of philosophy, but in the way that human behaviour in relation to its circumstances – daily living – is the prompt of philosophical speculation. But what kind of philosophy is coming through in these film studies of troubled people, or in Taylor-Wood's major series of 360 degree photographs made between 1995 and 2000, *Five Revolutionary Seconds*?

There are some expansive concepts with which to consider Taylor-Wood's concerns with muteness and tension – the suspended moments of human drama, which blur the boundaries between reaction and performance. Invariably, in Taylor-Wood's art, the subjects appear in some way captive. Throughout the many linear scenes of *Five Revolutionary Seconds*, we find ourselves compelled towards the details of a world in which the status of events (in which the dramatic action and the waiting seem to cancel one another out, making a weird syntax of time) has all but broken down, turning narrative into a frieze-like tableaux of oblique episodes. These people are captive in time.

Kierkegaard writes: '...and in this lies the mystery of existence, the fact that unfreedom makes a prisoner precisely

of itself. Freedom is constantly communicating; unfreedom becomes more and more shut-up, and wants no communication... . When freedom then comes in contact with shut-upness, it becomes afraid.'

Which takes us right into the landscape of Brett Easton Ellis at his most demoniacal – the world of *American Psycho*. In Taylor-Wood's exploration of such territory – of fear and claustrophobia – there is no such use of melodrama. For deriving from the warmth and precision of her images – their 'too-thereness' – is a simultaneous sense of distance, as though these were arrested scenes being acted out in some kind of lux theatre of the mind, where the very trappings of liberal-bourgeois comfort (and sometimes imperial-looking opulence) simply reinforce the feeling of captivity.

The interiors and environments of Taylor-Wood's films and photographs (with particular reference to the *Soliloquies*, 1998-2001, and *Five Revolutionary Seconds,* 1995-2000, with their dream-like fusion of familiarity and distance) often seem to have the feel of transitional, somewhat lifeless places, where all the comforts of a kind of Sunday-supplement lifestyle world are in place, but no feeling or humanity emerge from the surroundings. Heightened by the luxurious manner in which they are filmed or photographed, and ventriloquized in the arid, joyless demeanour of their inhabitants, the sense of these locations being thoroughfares (fitted out in the stock urban liberal bourgeois 'good taste' of the 1990s) appears a vital informant of Taylor-Wood's vision. (You could say the same, in the fiction of Easton Ellis, about his use of designer labels as evidence of a neurotic obsession with status.)

What is being identified by the characters and locations is the post-modernist enactment of 'unfreedom' – of characters captive in a world of frozen empathy, or subjectivity in suspension, which takes its bourgeois form as a kind of alienation in aspic. And we might remember that a recent communication from the Vatican redefined hell as an eternity of loneliness – a soul loneliness.

(Coincidentally, in a remarkable extension of Kierkegaardian thinking in relation to Taylor-Wood's art, the philosopher's 'Concept of Anxiety' takes as its principal conceits: silence, ventriloquism (people being given words which are not their own), tedium (as in the suspended state of waiting) and 'The Sudden'. This last term offers an immediate interpretation of the young male dancer in *Brontosaurus*, by taking as its central image the ballet dancer who can leap (see also Taylor-Wood's photograph *The Leap*, 2001) into a constantly sustained posture. 'The Sudden', defined by the ballet dancer's leap, was a term for the fear of continuity.)

So what might be the sum of all these obscure philosophical positions, when you look at the utterly modern, sometimes sumptuous, situations described by Taylor-Wood's art?

Between the tensions of *Killing Time* and Taylor-Wood's most recent works, there is an unwavering constancy of vision, a concern with the individual's silent – or is it silenced? – captivity within their circumstances, which has evolved through studies of human relationships to a current engagement with mortality itself, and is best summed up by the eighteenth-century tag for the presence of mortality in the midst of life and beauty: 'Et In Arcadia Ego'. The stage beyond this state is the acknowledgement of religious faith or spiritual belief as equally real to one's destiny.

Has Taylor-Wood, then, been an eighteenth-century artist all along? A philosophical enquirer into the nature of Beauty in relation to Death?

As the modernity of her subjects and their settings could be drawn straight from Joni Mitchell's lyrics of Hollywood's vacuity, or the fiction of Jay McInerney or Douglas Coupland, at their most vagued-out and bulimic on cultural materialism, so, at a pinch, do their desires correspond to the emotionally hot-flushed characters in Michael Houellebecq's astonishing novel *Atomised* – joyless parties filled with troubling or pointless sexual encounters, soliloquies of regret, random violence.

Here then is the descendant of mannered intrigue and allegorical pronouncement: society portraiture by way of Peter Greenaway's rotting swans and the ghost of Andy Warhol. But what emerges – or is emerging – is the inevitable encounter with the spirit's role in life – for which see Taylor-Wood's recreation of Michelangelo's *Pietà* (*Pietà*, 2001), in which the artist embodies her own career of straining tension, holding the actor Robert Downey Jr with the gentle compassion of a mother.

The most recent work I saw by Sam Taylor-Wood – the piece I returned to in her *Mute* show – was called *Poor Cow*. A photograph of a cow, facing you from the middle distance, with a gap in the hedgerow behind it. Taylor-Wood goes pastoral – the stylized landscape of eighteenth-century allegory. (A deliquescing still-life of fruit in the same exhibition, and a photograph of a bound ram.) Nature is perhaps the one source that can never be muted; as W.H. Auden's poem *Musé des Beaux Arts* describes, nature will always maintain its course, regardless of surrounding human activity or drama.

Taylor-Wood's *Poor Cow* (as either a symbol, or a representative of the tragic mishandling of the recent outbreak, in Britain, of foot and mouth disease, or as an animal *tabula rasa* on which we project our emotions) seems to do her work with her gaze – like any great portrait. The novelist Roger Grenier writes of the look of reproach we can see in the eyes of animals – it's a loving reproach, without getting sentimental.

Place *Poor Cow* (or *Bound Ram*) in the chain of development of Taylor-Wood's art, and the questions raised about destiny, captivity, action and silence, the 'shut-upness' and the fear of the fear, all point to the longing for redemption, a way out.

And perhaps that's it – for all of us, I mean. That what we might see in the art of Sam Taylor-Wood is a glimpse of that all-too-human shuffle between destiny and mortality ('each so deep and so superficial', sings Mitchell, 'between the forceps and the stone') with the partying and the glamour and the human algebra of modern urban life (flirtations, shouting matches, celebrities, restaurants, boredom) becoming the mirror of our own insecurity. Religion, as Jung noted, is derived from 'religere', 'to reflect'; and 'camera', just a hop and a skip down the etymological chain, means 'room'.

Michael Bracewell

The Unnaturalness of Reality

In his prose-poem, *The Double Room*, written in the early 1860s, Charles Baudelaire describes his rich impressions of an interior, and his experiences within it. He begins:

'A room that resembles a reverie, a truly spiritual room, where the stagnant atmosphere is lightly tinged with pink and blue.
Here the soul takes a bath of laziness, perfumed with regret and desire. – Something like twilight, bluish and pinkish; a dream of voluptuous pleasure during an eclipse.
The furniture has elongated, collapsed, languid shapes. The furniture seems to be dreaming, you might say endowed with a somnambular life, like vegetables and minerals. The fabrics speak a silent language, like flowers, like skies, like setting suns.
No artistic abomination on the walls. Compared to pure dream, to unanalysed impressions, a precise art, a concrete art, is blasphemy. Everything here possesses the abundant light and delicious darkness of harmony.
An infinitesimal scent of the most exquisite choice, mingled with the slightest wetness, swims in that atmosphere, where the drowsy mind is lulled by hothouse sensations.'

In such an atmosphere, time expands like a vapour, drifts and dissipates:

'No! There are no more minutes, there are no more seconds! Time has disappeared. Eternity now reigns, an eternity of delights!'

Unfortunately for Baudelaire his delights did not last so long, dissolving with the laudanum haze with which they were created and returning him to the familiar senses of his room and the relentlessness of everyday life:

'Time has reappeared; time reigns as sovereign now. And with that hideous old man the whole diabolical procession has returned, Memories, Regrets, Spasms, Fears, Anguishes, Nightmares, Rages, and Neuroses.'

There is a place in time where desire's sultry warmth becomes anxiety's icy sweat, and this is where Sam Taylor-Wood's work is often to be found. A man masks his shame with a hand, or his fear, his pleasure, as two others, the colour of peacocks and bruises, use words to intimate and intimidate; a woman in a silk dress the colour of old bones seals her mouth as a couple fuck under the glazed reflections of gilded mirrors and jaded eyes; a somnolent youth lies, watched, half-smiling, an arm outstretched, his complexion the colour of heroin. And everywhere, in the patterns of fabric, of paint, of people, can be found Baudelaire's observation that while the poor are forced to skimp on their sorrow, the rich wear theirs in full force.

There is a luxuriance in Taylor-Wood's work that makes some uncomfortable. In a culture of popular utility (and with a misplaced sense of the 'real'), images of the bourgeoisie are seen almost as a sign of moral failure. This sense of indignation is not new – indignation is seldom known for its originality – but is reminiscent of Thomas Carlyle's caustic Puritanism in the early- to mid-nineteenth century. Carlyle raged against fashionable Londoners' determination to be 'so very unsubstantial in their whole proceedings [...]. From day to day and year to year the problem is not how to use time, but how to waste it least painfully.' Carlyle was writing at a time when the figure of the dandy was making his turtle-paced way through the *mille-feuille* of elegant society, and he objected to the dandy's desire to be no more than 'a visual object or thing that will reflect rays of light. Your silver or your gold [...] he solicits not; simply the glance of your eyes [...]. [D]o but look at him, and he is contented.'

The dandy does not work, or if he does, it is masked behind a cultivated appearance of leisure. For Baudelaire, the dandy represented 'a new kind of aristocracy', albeit one founded upon neither wealth nor birth but a self-made elegance and 'native energy', and at a time when the aristocracy itself was most despised, that of the dandy would prove 'all the more difficult to shatter as it will be based on the most precious, the most enduring faculties, on the divine gifts that work or money are unable to bestow'. However, if the dandies were the new aristocrats, they did not particularly imitate their predecessors; rather, the times were such that even the future George IV found it advisable to follow rather than lead. And yet despite their historical connections to the rich and powerful, the dandy, especially the Baudelairean dandy, is a figure of rebellion with a 'characteristic quality of opposition and revolt'. It is hardly surprising, then, that the dandy should be seen as the avant-garde of the historical avant-garde and become synonymous with the figure of the artist. Perhaps even more than this, as the literary critic Jessica Feldman has noted, 'the dandies of literature are often created by artists who are also dandies. The hall of mirrors is the dandy's ancestral home. In a dizzying reflexivity, the dandy created within the work of art – Pelham or Onegin or Don Juan – is actualized, rendered 'real' in print by the living, breathing dandy-writer who chooses to make of himself and his daily life a fiction.'

There's a description of Manet's barmaid at the Folies-Bergère – her face has 'a character [that] derives from its not being bourgeois – and having that fact almost hidden' – and I'm reminded of it looking at a photograph of Sam Taylor-Wood. The pose is confident and self-assured; the eyes meet ours; a hand rests against a slim hip and grips a cable release (it is a self-made image of the self-made); the hair is thick and casually styled; the clothes are simple, sharp; and of course the shirt is white and the suit is black. This is how Sam Taylor-Wood presented herself on the cover of a supplement in *The Observer* recently. She is also holding a hare in her hand, which adds to the simple punning of the title, *Self Portrait in a Single Breasted Suit with Hare*, referring to the terrible effects following her treatment for cancer. At the top of the page the supplement's title, also in black and white, announces: *Life*. It is as crisp an image of contemporary dandyism as one could hope for, of 'the joy of astonishing others', as Baudelaire had it, 'and the proud satisfaction of never oneself being astonished. A dandy may be blasé, he may even suffer; but in this case, he will smile like the Spartan boy under the fox's tooth.' Or as contemporary journalism has it: 'How artist Sam Taylor-Wood survived breast and colon cancer – and still kept her sense of humour'. It seems that Baudelaire was right to wear black in mourning of a culture in decline, after all.

The dandy dressed smartly, simply, almost soberly, and almost always in black, 'the necessary garb of our suffering age', thought Baudelaire. Although not obviously 'showy', it remained a form of display, albeit a display of character or attitude rather than wealth or birth (as such, Taylor-Wood's self-portrait should be seen alongside David Bailey's photographs of Michael Caine or the Kray twins). Taylor-Wood's photograph also introduces another important subject, that of gender. The dandy had often been seen as a figure of sexual ambivalence, although most often it is of male adoption of female characteristics – one might think of the deliberate effeminacy of the Count d'Orsay, for example. But the dandy allows that the opposite might also occur, or rather it renders such binary oppositions meaningless. In the late nineteenth and early twentieth century, it was not uncommon to find middle-class women, particularly those connected to the development of modernism, wearing men's clothing. Cross-dressing allowed the possibility of reconsidering the categories of masculine and feminine as they had been culturally defined, and of redefining them through culture. It is hardly surprising, then, that many of these women adopted the look of Baudelaire's 'modern hero', the understated androgynous elegance of black suit, white shirt. There are the paintings of Romaine Brooks, for example, her 'series of modern women', which include the monocled severity of *Una, Lady Trourbridge*, 1923, (who had just left her husband for Radclyffe Hall, author of the lesbian novel *The Well of*

Self Portrait in a Single Breasted Suit with Hare 2001
C-type print 152 x 104.5 cm

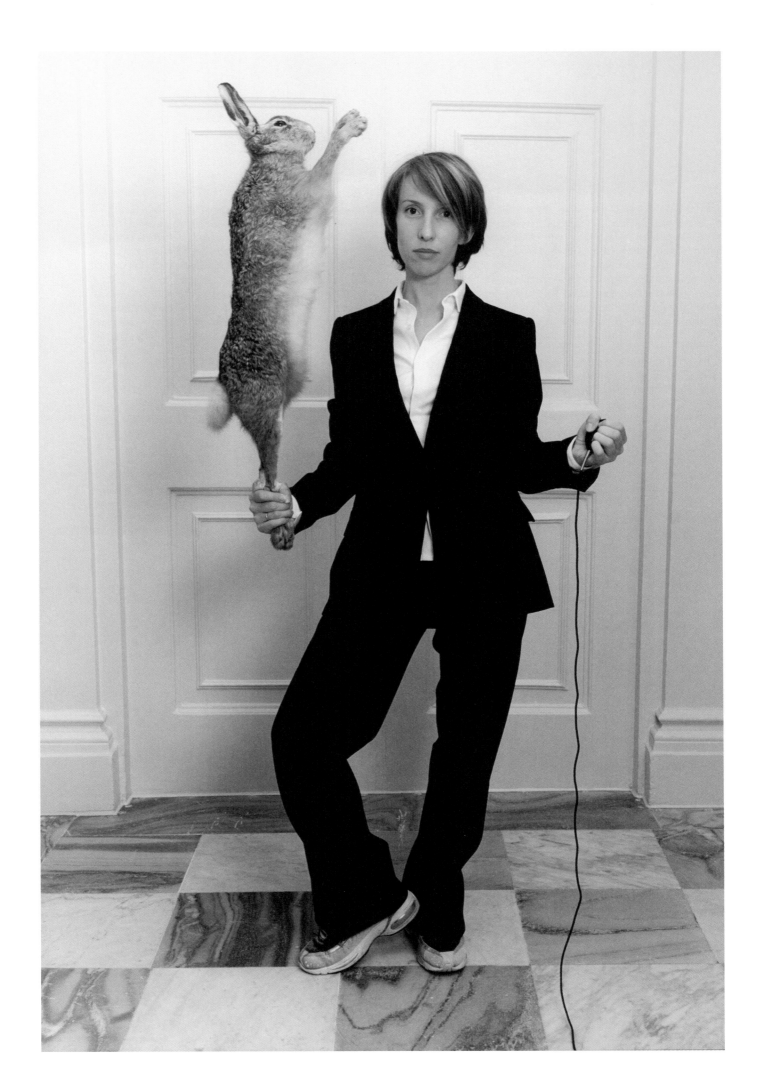

Loneliness), the tousled sensuality of *Peter (A Young English Girl)*, 1923–24, (actually the painter Gluck), and Brooks' own bleak *Self-Portrait*, 1923; there is Alfred Stieglitz's 1921 portrait of the painter Georgia O'Keeffe, uncompromising in her dishevelled simplicity; and there is Claude Cahun's *Self-Portrait* taken around the same time, her suit black, her scarf white, and her head shaved, like Baudelaire's. Her right hand rests on her hip, her pose almost identical to Taylor-Wood's. To its title we might almost add (in a double-breasted suit with no hair).

The dandy is a figure of transformation and, as such, it is a figure that can itself become transformed. We might even recognize such a process in Pier Paolo Pasolini's first film, *Accattone*, 1961. The film is set mainly in the slums of Rome, the borgate, and follows the squalid life – and death – of the pimp, Accattone. The film opens with a man, Scucchia, walking past a street café with an armful of flowers. He calls to those seated outside, with mock incredulity, that he'd never seen them in daytime, only at night. 'Are your girls on strike?', he enquires. 'Not dead yet? I heard that work kills people', comes the mocking reply. When Scucchia responds that it's an honest death, he is told to, 'Stop working and join Metro-Goldwyn-Mayer'. The implication is that this is exactly what the others have already done, thereby confirming Orwell's observation from almost thirty years earlier, that: 'You may have threepence in your pocket and not a prospect in the world; but in your new clothes you can stand on the street corner, indulging in a private daydream of yourself as Clark Gable or Greta Garbo.' And we soon realize that clothes are important for Accattone. When he returns home to find that his girlfriend (and employee) Maddalena has injured her leg in an accident, one of the first things he is told is, 'I'd been to pay 1000 lire towards the pullover I bought you. I must pay 1000 lire every morning'.

These are scarcely sympathetic characters – at one point Accattone steals the gold necklace from his young son, from whom he is estranged, in order to buy some clothes for his new 'girl' following Maddalena's imprisonment – although we have already noted that the dandy is in many ways an antagonistic figure. Just as the dandy was, for Baudelaire, part of a new self-made aristocracy, for Pasolini, characters like Accattone were part of an 'aristocracy of labour', an aristocracy which did not work ('Work! That's blasphemy!', screams one man at the beginning of *Accattone* as he runs away, hands over his ears). Like the dandy, Pasolini's characters have only the vaguest of relationships with the production of consumer

capitalism; instead they're unemployed, thieves or layabouts. Even those connected to the 'oldest profession' – Accattone himself, and his girls – are never seen actually making money. It was the dandy's lack of utility that so angered Carlyle and so pleased Baudelaire, and it is the same uselessness to functional society that made these characters so important to Pasolini. He had recognized, like those writers one hundred years before him, that they were representing him as much as he was representing them.

Given Pasolini's well-documented hatred of the bourgeoisie, it might seem an act of deliberate perversion to introduce him into this discussion, yet I believe that there are interesting connections which can be made between him and Taylor-Wood, in both their subject matter and their methodologies. Influence – whether conscious or not – never requires an absolute coincidence of approaches, and we must remember that no artist is without his or her own contradictions. If meaning is created in the relationships between things as much as within the things themselves – and this is as true of an artist's practice as it is of the works that make up that practice – it is perhaps film, of all the media, that most clearly shows this. In 1926, one of the most important early writers on film, Siegfried Kracauer, described the inherently fragmented nature of film production after visiting the UFA studios in Neubabelsberg: 'Their sequence does not follow the order of the represented events. A person's fate may already have been filmed even before the events leading up to it are determined; a reconciliation may be filmed earlier than the conflict it resolves. The meaning of the plot emerges only in the finished film; during the gestation it remains unfathomable.'

Film, then, is essentially a medium of collage, and this is what gives it its dream-like quality (indeed, it was this aspect of film that reminded Kracauer of dreams, 'in which the fragments of waking life mingle in confusion'). Pasolini regarded film as inherently dream-like for this very reason, and we can find the same process taking place in Taylor-Wood's work also, whether her films or her cinematic photographs. It is certainly true of the series *Five Revolutionary Seconds*, 1995-2000, each a photograph of 'a room that resembles a reverie', to awaken Baudelaire once more, and of the related *Soliloquy* series, 1998-2001, where the viewer is invited to enter the imaginative space of the main character ('I wanted the *Soliloquies* to be more dream-like').

It is true of *Pent-Up*, 1996, also, its row of five projection screens forming yet another panorama of human emotions.

In each an individual seems to mark out his or her own psychic territory, a territory that is made to expand, to contract, or to hover uncertainly. A women confronts us, walking purposefully through a city's streets; an older man sits pensively in an armchair, attempting to understand; a younger man prowls his bright minimalist apartment; a young woman drinks and smokes by herself in a darkened bar; and another young man stands crumpled and confused in a back garden. We might recognize some of these people, either the people themselves or the people they play. And all of them seem to talk to themselves, of embarrassment and regret, uncertainty and desire, as though talking would help, as though words would make sense of it all.

It soon becomes clear, however, that we are not witnessing an incoherent collection of private – and perhaps psychotic – monologues, but rather some expanded conversation between all the characters, a conversation where the only possibility for understanding lies in bringing together the disparate. And yet even when we recognize this, the narrative refuses to become fixed, responses shifting between characters as though sliding out of synchronization. There is a narrative logic to what is being said, but not to who is saying it, and to whom it seems to be said. The characters say things that could have been said by someone else (indeed, the script for the piece shows that Taylor-Wood has altered who speaks as much as what is spoken, even, it seems at times, writing dialogue first and only later ascribing it to a character). For all their candidness, their bluntness, they are not so much speaking their mind as speaking someone else's; or, to have Umberto Eco speak for me, 'This way of finding oneself in the other, this objectification, is always more or less a form of alienation, at once a loss of oneself and a recovery of oneself'.

The film theorist André Bazin argued (contra Kracauer and others) that montage was the enemy of cinema and that true cinema 'depends upon a simple photographic respect for the unity of space'. Like much of Taylor-Wood's work, *Pent-Up* has an uncertain relationship to any simplified realism. Each screen shows a single take – without edits – lasting the length of the work, ten minutes and thirty seconds. As such, it would seem to satisfy Bazin's requirements for a realist cinema, and yet we know that the space of the work – as installation and as dialogue – is far from unified, expanding beyond its frame and across time. Indeed, the emphasis on artifice, which we have discussed, destroys any lingering sense of a representational illusionism as Bazin would have had it.

This is true, also, of a more recent work, *Third Party*, 1999. Rather than bringing together a number of events previously separated by time and space, however, *Third Party* explodes that which is happening at a single event taking place in one room, the party alluded to in the title. The party is filmed by seven cameras, six of them fixed and one hand-held, and each records, in a single shot, what happens over ten minutes. The projections are of varying sizes this time and are placed around the gallery in such a way as to replicate the space of the party itself, so that a character on one screen might seem to look across the room towards someone else. The effect is such that, standing between the projections, amongst them, the viewer is able to follow an actor's gaze and look where he or she is looking. To some extent, this is film-making at its most representational, an attempt to show, as simply as possible, what is happening in a single room between a handful of people; yet, at the same time, it makes plain the impossibility of being able to do so, and forces us to actually situate ourselves amongst the means of its own reproduction. Perhaps this might be thought of in terms of Pasolini's film theory, and his notion of the 'infinite shot-sequence', which was cinema as absolute mimesis. Of course, such completeness is impossible, as each actual shot is merely one realization of what might have been possible (and there could have been other realizations, other shots, other takes) yet each shot recalls this wholeness, alludes to it. An actual film is not reality itself, although it is made from it. The ideal cinema consisted of reality that was unmanipulated, and yet selected. Thus, Pasolini was able to insist on his art and on reality at the same time; Taylor-Wood is able to do likewise.

In *Third Party*, two people, both young, and both attracted and attractive, flirt in the corner of a room, watched by a man brooding upon the sofa. After some time, he approaches the woman, suggesting that they leave. 'Five minutes', she replies, and reverts her attention. 'The whole film, as a matter of fact, is a story of persuading,' noted Alain Robbe-Grillet of *Last Year at Marienbad*, (which he wrote and which was directed by Alain Resnais in 1961, and with which the *Five Revolutionary Seconds* series might be considered) and perhaps the same could be said of *Third Party*. Here, too, we do not know the names of the people, their characters, or the relationships between them (although we are invited to speculate) and the same is true of people we see in other works by Taylor-Wood, such as *Travesty of a Mockery*, 1995, *Sustaining the Crisis*, 1997, or *Pent-Up*. For Robbe-Grillet, it is the nature of film to create an immediate presence that appears and then dis-

appears: 'This man, this woman begin existing only when they appear on the screen for the first time; before that they are nothing; and, once the projection is over, they are again nothing. Their existence lasts only as long as the film lasts. There can be no reality outside the images we see, the words we hear.' What we are watching in a work like *Third Party*, or in a film by Fellini, *8 1/2*, 1963, perhaps, is the film itself taking shape. The process of the film is part of the subject of the film, and to some extent they both record their own coming into existence, and enter into their own spectacle.

While discussing the making of *Accattone*, Pasolini remarked that 'there is nothing more technically sacred than a slow pan'. His remark suggests a number of works by Taylor-Wood, most especially the *Soliloquies*, the lower part of which is made using the slow pan of the panoramic camera. Their reference to more traditional forms of religious imagery – the altarpieces of the Quattrocento – is of course deliberate, although unlike their Renaissance predecessors, the *Soliloquies* refuse to present a simple narrative from which the viewer might receive moral instruction. 'I wanted to depict the same separation', Taylor-Wood has commented, 'the different formal sense between above and below, between the sublime and the physical, immaterial and material.' Pasolini thought of the poetic as structured in a similar way, a civilized surface resting upon a substratum of the irrational, the value of each depending upon the presence of the other. Like the palazzo of sadism in *Salò*, 1975, the mannered eroticism within the swelling, swaying interior of a public baths in *Soliloquy II*, 1998, is sealed from the outside world. Above it a man stands, bare-footed and bare-chested, surrounded by dogs as feral as he, his belt unable to contain him (nowhere near), a gold cross around his neck, and looking like a Mannerist saint. Pasolini did this often, bestowing sacredness upon the most lowly and humble – the fight, the beating, and the stealing within *Accattone* are all accompanied by Bach's *St. Matthew's Passion*, for example. (He did it also by citing compositions from eminent artworks, and it is interesting to note that many of the same works – by Da Vinci, Michelangelo, Mantegna and Velàzquez have been cited by Taylor-Wood also.) Taylor-Wood has made reference to other religious works, of course. Zurbaràn's *The Bound Lamb ('Agnus Dei')*, c.1636-40, was the inspiration for the photograph *Bound Ram*, 2000, we are told, yet William Holman Hunt's *The Scapegoat*, 1854, might prove more relevant to this discussion. The Middle East was important for the Pre-Raphaelite painter because it gave him the opportunity to combine fantasy and myth

with detailed realism. 'In the city there were some buildings and a mosque with marble inlaid work that seemed to belong to the time of Harun al Raschid', he wrote in a letter, thereby combining contemporary description with the magic of the *Thousand and One Nights* (just as Pasolini did when he filmed the fables as the final part of his *Trilogy of Life* in 1974). It was in this environment that Hunt attempted to depict Biblical scenes with an almost documentary accuracy – Hunt visited many of the actual sites while working on his paintings – and this can be seen in *The Scapegoat* also. It is a wretched animal, with an expression that prompts scorn rather than pity. It stands unsteadily, its head hanging low, perhaps unsettled by its hooves that have broken through the crust at the edge of the Dead Sea. Its coat is of a sickly colour, something that is only emphasized further by the red fillet that is bound around the animal's horns (in accordance with the promise in Isaiah: 'Though your sins be as scarlet, they shall be white as snow', should God accept this offering of Atonement). The animal in Taylor-Wood's photograph is equally abject, its wool matted and discoloured, as it pisses fear in the corner of a market. It is bound with red twine also, although around its front legs rather than its horns, its presence here useful rather than symbolic. Hunt aspired to 'religious naturalism', Pasolini to 'a technique of sacredness'. I think that either description would prove apposite here.

At the beginning of this text, Baudelaire remarked that 'compared to pure dream [...] a precise art [...] is blasphemy'. Perhaps he was right. Some critics were offended by Hunt's portrayal of 'exact material truth', and Pasolini was, indeed, convicted of blasphemy. However, both attempted to find the sacred amongst the most simple, and to represent it in such a way as to value both these qualities. 'In *Accattone*, I walk above an abyss, one side formed by the religious epic, the other by realist 'naturalism'...,' remarked Pasolini. One might swear – on oath or as profanity – that Taylor-Wood does the same.

Jeremy Millar

1967 Born, London
1990 Graduated Goldsmith's College, London
Currently lives and works in London

Awards

1997 Illy Café Prize for Most Promising Young Artist, Venice Biennale

Solo Exhibitions

2002 *Films and Photography*, Stedelijk Museum, Amsterdam
Sam Taylor-Wood. To be or not to be, Shiseido Gallery, Tokyo

2001 *Mute*, White Cube², London
Künstlerverein Malkasten, Düsseldorf
Photographies et films, Centre national de la photographie, Hôtel Salomon de Rothschild, Paris

2000 Centrum Sztuki Wspólczesnej Zamek Ujazdowski, Warsaw
Espacio Uno, Museo Nacional Centro de Arte Reina Sofiá, Madrid
Matthew Marks Gallery, New York

1999 *Third Party*, Württembergischer Kunstverein, Stuttgart
Directions, Hirshhorn Museum and Sculpture Garden, Washington

1998 Prada Foundation, Milan
Donald Young Gallery, Seattle

1997 *Sustaining the Crisis*, Regen Projects, Los Angeles
Five Revolutionary Seconds, Sala Montcada de la Fundació "la Caixa", Barcelona
Kunsthalle, Zürich; Louisiana Museum of Modern Art, Humlebæk

1996 *16mm*, Ridinghouse Editions, London
Pent-Up, Chisenhale Gallery, London; Northern Gallery for Contemporary Art, Sunderland

1995 Galleri Andreas Brändström, Stockholm
Travesty of a Mockery, Jay Jopling/White Cube, London

1994 *Killing Time*, The Showroom, London

Selected Group Exhibitions

2001 *6 Biennale d'art contemporain de Lyon*, Musée d'Art Contemporain de Lyon
A Baroque Party / Moments of Theatrum Mundi in Contemporary Art, Kunsthalle Wien, Vienna
The Body of Art – The Valencia Biennial, Valencia, Spain

2000 *Media City Seoul 2000*, Seoul, Korea
Une mise en scène du réel: artiste/acteur, Villa Arson, Nice
Out There, White Cube², London
The Self is Something Else. Art at the end of the 20th century, Kunstsammlung Nordrhein-Westfalen, Düsseldorf
Sincerely yours. British art from the 90s, Astrup Fearnley Museum of Modern Art, Oslo

1999 *Carnegie International 1999/2000*, Carnegie Museum of Art, Pittsburgh
Talk Show. The Art of Communication in the 90's, Von der Heydt-Museum, Wuppertal; Haus der Kunst, München

1998 *Emotion. Young British and American Art from the Goetz Collection*, Deichtorhallen, Hamburg
Turner Prize, Tate Gallery, London
New Photography 14, The Museum of Modern Art, New York
Video: Bruce Nauman, Tony Oursler, Sam Taylor-Wood, San Francisco Museum of Modern Art, San Francisco
Real/Life: New British Art, Museum of Contemporary Art, Japan (British Council Touring Exhibition)
Art from the UK: Angela Bulloch, Willie Doherty, Tracey Emin, Sarah Lucas, Sam Taylor-Wood, Sammlung Goetz, Munich
Close Echoes. Public Body & Artificial Space, City Art Gallery, Prague; Kunsthalle, Krems

1997 *New British Video Programme*, Museum of Modern Art, New York
Stills: Emerging Photography in the 1990s, The Walker Art Center, Minneapolis
Dimensions Variable. New Works for the British Council Collection, The British Council Touring Exhibition
Group Exhibition, PS1, New York
2nd Johannesburg Biennale. Trade Routes: History and Geography, Johannesburg
5th Istanbul Biennial, Istanbul
Sensation. Young British Artists from the Saatchi Collection, Royal Academy of Arts, London; Hamburger Bahnhof, Berlin;
Brooklyn Museum, New York
Pictura Britannica. Art from Britain, Museum of Contemporary Art, Sydney; Art Gallery of South Australia, Adelaide;
City Gallery, Wellington, New Zealand
Truce: Echoes of Art in an Age of Endless Conclusions, Site Santa Fe, New Mexico
Home Sweet Home, Deichtorhallen, Hamburg
Montréal Film Festival, Montréal
Venice Biennale, Venice
Treasure Island. A View of Contemporary Art, Fundação Calouste Gulbenkian, Lisbon
Campo 6, The Spiral Village, Turin, Italy; Bonnefanten Museum, Maastricht

1996 *Full House: Young British Art*, Kunstmuseum, Wolfsburg
Life / Live, Musée d'art Moderne de la Ville de Paris; Centro de Exposições do Centro Cultural de Belém, Lisbon
The Event Horizon, The Irish Museum of Modern Art, Dublin
Toyama Now '96, The Museum of Modern Art, Toyama
Manifesta 1, Rotterdam
Prospect 96, Kunstverein, Frankfurt

1995 *The British Art Show 4*, Manchester; Edinburgh; Cardiff
Masculin / Feminin, Centre George Pompidou, Paris
Brilliant! New Art from London, Walker Art Centre, Minneapolis; Contemporary Art Museum, Houston
Perfect Speed, Macdonald Stewart Art Centre, Guelph, Ontario; University of Southern Florida Contemporary Art Museum, Tampa
Aperto '95, Le Nouveau Musée/Institut d'Art Contemporain, Villeurbanne, France
General Release, Venice Biennale
Corpus Delicti, Kunstforeningen, Copenhagen

1994 *Not Self-Portrait*, Karsten Schubert Gallery, London
Don't Look Now, Thread Waxing Space, New York

1993 *Consider the end. Sam Taylor-Wood and PPQ*, HQ, Redchurch Street, London
Lucky Kunst, Silver Place, London
Wonderful Life, Lisson Gallery, London
Close Up, Time Square, New York
Information Dienst, Kunsthalle, Stuttgart

1992 *Group exhibition*, Clove Two Gallery, London
Showhide Show, Anderson O'Day Gallery, London

Selected Bibliography

Solo Exhibition Catalogues / Publications

Sam Taylor-Wood, The Showroom, London 1994
O'Pray, Michael and Jake Chapman. *Pent-Up. Sam Taylor-Wood*, Jay Jopling, Chisenhale Gallery, London and Sunderland City Art Gallery 1996
Taylor-Wood, Sam. *Unhinged*, Bookworks, London 1996
Martínez, Rosa and Gregor Muir. *Five Revolutionary Seconds*, Fundació "la Caixa", Barcelona 1997
Bürgi, Bernhard, Kjeld Kjeldsen, Waldemar Januszczak and Will Self. *Sam Taylor-Wood*, Kunsthalle Zürich & Louisiana Museum of Modern Art 1997
Ferguson, Bruce, Nancy Spector, Michael Bracewell and Germano Celant. *Sam Taylor-Wood*, Prada Foundation, Milan 1998
Viso, Olga. *Directions. Sam Taylor-Wood*, Smithsonian, Hirshhorn Museum and Sculpture Garden, Washington 1999
Hentschel, Martin and Michael O'Pray. *Third Party*, Württembergischer Kunstverein Stuttgart / Hatje Cantz Publishers 1999
O'Pray, Michael. *Sam Taylor-Wood*, Centre for Contemporary Art Ujazdowski Castle, Warsaw 2000
Taylor-Wood, Sam. *Contact*, Booth-Clibborn Editions, London 2001
Januszczak, Waldemar. *To be or not to be. Sam Taylor-Wood*, Shiseido Corporate Culture Department, Tokyo 2002
Visser, Hripsimé. *Sam Taylor-Wood. Films and Photography*, Stedelijk Museum, Amsterdam 2002

Group Exhibition Catalogues

Behrndt, Helle and Torben Christensen. *Corpus Delicti*, Kunstforeningen, Copenhagen 1995
Aperto '95, Le Nouveau Musée, France 1995
Brilliant! New Art from London, Walker Art Centre, Minneapolis 1995
Cork, Richard, Rose Finn-Kelcey and Thomas Lawson. *British Art 4*, The South Bank Centre, London 1995
General Release, Venice Biennale, 1995
Martinez, Rosa, Viktor Misiano, Katalin Neray, Hans-Ulrich Obrist and Andrew Renton. *Manifesta 1*, Boymans van Beuningen, Rotterdam 1996
The Event Horizon, Irish Museum of Modern Art, Dublin 1996
Obrist, Hans-Ulrich (ed.). *Life/Live*, Musée d'Art Modern de la Ville de Paris 1996 (Two volumes)
Molder, Jorge, Rui Sanches and Ana de Vasconcelos a Melo. *A Ilha do Tesouro (Treasure Island)*, Fundação Calouste Gulbenkian, Lisbon 1996
Bonami, Francesco. *Truce: Echoes of Art in an Age of Endless Conclusions*, Site Santa Fe, New Mexico 1997
Murphy, Bernice (ed.) *Pictura Britanica. Art from Britain*, Museum of Contemporary Art, Sydney 1997
Adams, Brooks, Lisa Jardin, Martin Maloney, Norman Rosenthal and Richard Shone. *Sensation: Young British Artists from the Saatchi Collection*, Royal Academy of Arts, London 1997
Fereli, Melih. *5th International Istanbul Biennial*, Istanbul Foundation for Culture and Arts 1997
Gallagher, Ann. *Dimensions Variable*, The British Council 1997
Button, Virginia. *The Turner Prize 1998*, Tate Gallery, London 1998
Grynsztejn, Madeleine. *Carnegie International 1999/2000*, Carnegie Museum of Art, Pittsburgh 1999
Thorkildsen, Åsmund, Øystein Ustvedt. *Sincerely Yours*, Astrup Fearnley Moderne Kunst, Oslo 2000
Folie, Sabine and Michael Glasmeier. *A Baroque Party. Moments of Theatrum Mundi in Contemporary Art*, Kunsthalle Wien 2001
Roncero, Rafael. *Espacio Uno III*, Museo Nacional Centro de Arte Reina Sofiá, Madrid 2001

Periodicals

Archer, Michael. 'Piss and Tell', *Art Monthly*, December 1993/January 1994, no.172, pp.18-19
Bracewell, Michael. 'Sam Taylor-Wood', *Frieze*, September/October 1994, no.18, pp.58-59
Nilsson, Hakan. 'Sam Taylor-Wood: Chisenhale Gallery', *Material*, 1996
Muir, Gregor. 'Sam Taylor-Wood', *Frieze*, April 1996, Issue 27, pp.79-80
Birnbaum, Daniel. 'Sam Taylor-Wood', *Artforum*, November 1996, pp.88-89
Williams, Gilda. 'Sam Taylor-Wood: Chisenhale Gallery', *Art + Text*, February/April 1997, no.56, pp.80-81
Bonami, Francesco. 'Sam Taylor-Wood', *Flash Art*, March/April 1997, pp.96-100
Morgan, Jessica. 'Sam Taylor-Wood', *Grand Street*, 1998, no.65, pp.224-231
Hilty, Greg. 'Sam Taylor-Wood: The Experience of the Separation', *Art Press*, July/August 1998, no.237, pp.42-46
Ferguson, Bruce. 'Sam Taylor-Wood', *Bomb*, Fall 1998, no.65, pp.42-50
Roberts, James. 'Making a Drama Out of a Crisis', *Frieze*, 1999, Issue 44, pp.50-55
Bronfen, Elizabeth, Francesco Bonami and Ewa Lajer-Burcharh. 'Sam Taylor Wood', *Parkett*, 1999, no.55, pp.112-151
Frankel, Donald. 'Sam Taylor-Wood: Matthew Marks Gallery', *Artforum*, May 2000, no.9, p.177
Searle, Adrian. 'The lady vanishes', *The Guardian*, 1 December 2001, p.4
Januszczak, Waldemar. 'Cancer, mortality, art', *Sunday Times (Culture)*, 2 December 2001, p.17
Dorment, Richard. 'Spirit of the age', *Daily Telegraph*, 22 December 2001, p.A1

Sam Taylor-Wood would like to thank the following:
Patrick Borgen, Michael Bracewell, Irene Bradbury, Martin Caiger-Smith, Clare Carolin,
Jake Chapman, Joe Disa, Stephanie Dorsey, Dan Edwards, Susan Ferleger Brades, Daniela Gareh,
Sophie Greig, Angelica Jopling, Jay Jopling, Matthew Marks, Pierre Landry, Dixie Linder,
Honey Luard, Zoë Manzi, Seamus McGarvey, Harland Miller, Jeremy Millar, Dr. Larry Norton,
Mike Rundell, Annushka Shani, Dr. Maurice Slevin, Gerhard Steidl, Andrew Turner.

First English language edition 2002 published by Steidl Publishers

Essays © Michael Bracewell and Jeremy Millar 2002
Interview © Sam Taylor-Wood and Hayward Gallery, London 2002
Artworks © Sam Taylor-Wood 2002
For this edition © Steidl Publishers

Design: Miles Murray Sorrell FUEL

Scans by Steidl's digital darkroom. Printing by Steidl, Göttingen
Steidl, Düstere Strasse 4, D-37073 Göttingen
Telephone +49 551 49 60 60 Fax +49 551 49 60 649

ISBN 3 88243 830 4 (Steidl Publishers)

Printed in Germany

Steidl books are distributed in USA by DAP, rest of the world by Thames & Hudson.